DAY
OF the
DeaD

KITTY WILLIAMS AND STEVIE MACK

GIBBS SMITH
TO ENRICH AND INSPIRE HUMANKIND

TO MY AUNT Sally Cano who first introduced me to the color and wonder of Mexico. How I wish she could have lived to see this book. Descansa en paz, tía.

—KITTY WILLIAMS

TO MY HUSBAND, Mike Grassinger, for his steadfast support and encouragement over the years so that I could follow my dreams.

—STEVIE MACK

First Edition
15 14 13 12 6 5 4 3

Text and photographs © 2011 by Kitty Williams and Stevie Mack

Published by
Gibbs Smith
P.O. Box 667
Layton, Utah 84041

1.800.835.4993 orders
www.gibbs-smith.com

Printed and bound in China
Gibbs Smith books are printed on either recycled, 100% post-consumer waste, FSC-certified papers or on paper produced from sustainable PEFC-certified forest/controlled wood source. Learn more at www.pefc.org.

Library of Congress Cataloging-in-Publication Data

Williams, Kitty.
 Day of the dead / Kitty Williams and Stevie Mack.
 p. cm.
 ISBN 978-1-4236-2052-5
 1. All Souls' Day—Mexico. 2. All Souls' Day—Southwest, New. 3. Mexico—Religious life and customs. 4. Southwest, New—Religious life and customs. I. Mack, Stevie. II. Title.
 GT4995.A4W55 2011
 394.266—dc22
 2011006570

ACKNOWLEDGMENTS

While this book represents the cumulative efforts of many, there is one very special person who was truly the guiding force behind it all, and that is Mary Jane McKitis. Thanks Mary Jane. In every way, you made this happen!

We'd also like to thank the great folks at Gibbs Smith for giving us the opportunity to work with them on one of our favorite topics. In particular, we are grateful to editors Madge Baird and Bob Cooper for shepherding us through the process.

Thanks, too, to our excellent staff at CRIZMAC for holding down the fort while we traveled to Mexico to complete the necessary photography and research.

We are also grateful to Zeny and Reyna Fuentes, Vivian Harvey, Bob Baker, and Rosemary and Mike Davis for their contributions.

And finally—especially—to the warm and gracious Mexican people, for sharing this beautiful aspect of their culture with us, generously providing us with a window into their world.

Kitty Williams: I'd like to thank my daughter, Mariah, who endured too many dinners of Easy Mac while I did just a little more work on "the book." I'm also grateful to my family and friends, who never stopped believing (or if they did, were wise enough not to mention it) that someday there really would be a book; and especially my mom and dad: You've done far more proofreading over the years than was in your original parental job description, and it is greatly appreciated.

Stevie Mack: I want to thank all of my family, whose encouragement and belief in this project was steadfast throughout; and Joni Torres, whose assistance with the photography was crucial to the successful outcome.

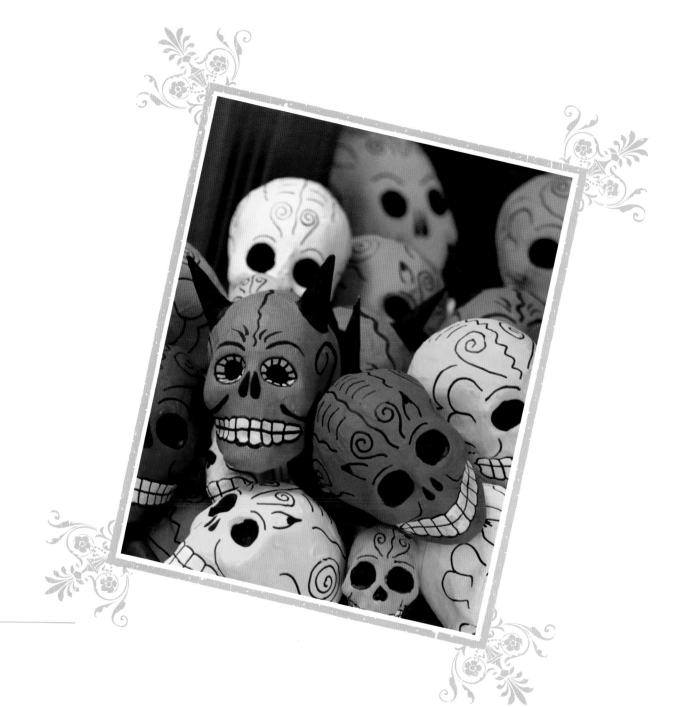

contents

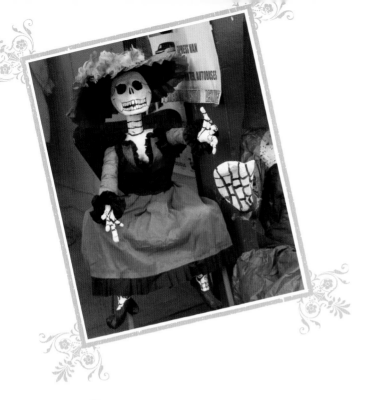

8 **iNTRODUCTiON**

17 **LiFE From DEath:** ORIGINS

29 **FEastinG and REvelry:** CELEBRATING WITH THE SPIRITS

71 **GRiNNiNG SKULLS and DancinG SKELETONS:** FOLK ART

109 **Savoring Tradition:** CREATING A PERSONAL CELEBRATION

128 **Resources**

To the inhabitant of New York, Paris, or London,

death is a word that is never uttered because it burns the lips.

The Mexican on the other hand, frequents it, mocks it,

caresses it, sleeps with it, entertains it;

it is one of his favorite playthings and his most enduring love.

—OCTAVIO PAZ
THE LABYRINTH OF SOLITUDE

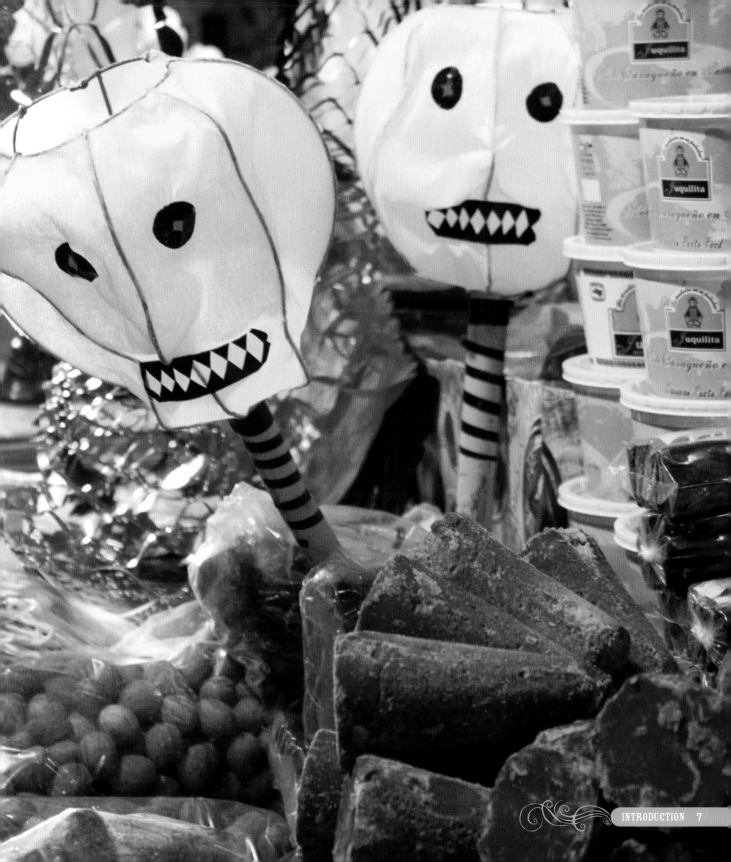

INTRODUCTION

Row after row of colorful sugar coffins and skulls line the stalls of the bustling market. Names piped in icing on the skulls' foreheads read "Pedro," "Maria," "Juan," "Lupe," and so on. Young and old alike purchase these confections to give to friends and sweethearts, conveying a shared friendship or love so strong it will last not only through this life but into the next. Other stalls are brimming as well—with candles of every shape and size and fragrant bundles of incense.

On a nearby side street an impromptu flower market has sprung up. Large pickup trucks arrive, filled to overflowing with cargoes of bright gold and orange marigolds, fuzzy magenta cockscomb, and bunches of delicate baby's breath. At a small chocolate factory across the street the grinding machines whirr constantly as housewives await their turns, clutching worn pieces of paper with scribbled recipes passed down through the years. There is much cooking to be done—chicken or turkey with spicy chocolate *mole* sauce, tamales, enchiladas, and large clay pots filled with hot chocolate or sweet coffee, called *café de la olla*. The cacao beans must be ground with just the right amounts of cinnamon, almond, or vanilla for each woman's personal recipes.

Every year, from mid- to late October, these scenes are repeated throughout Mexico, especially in areas with large

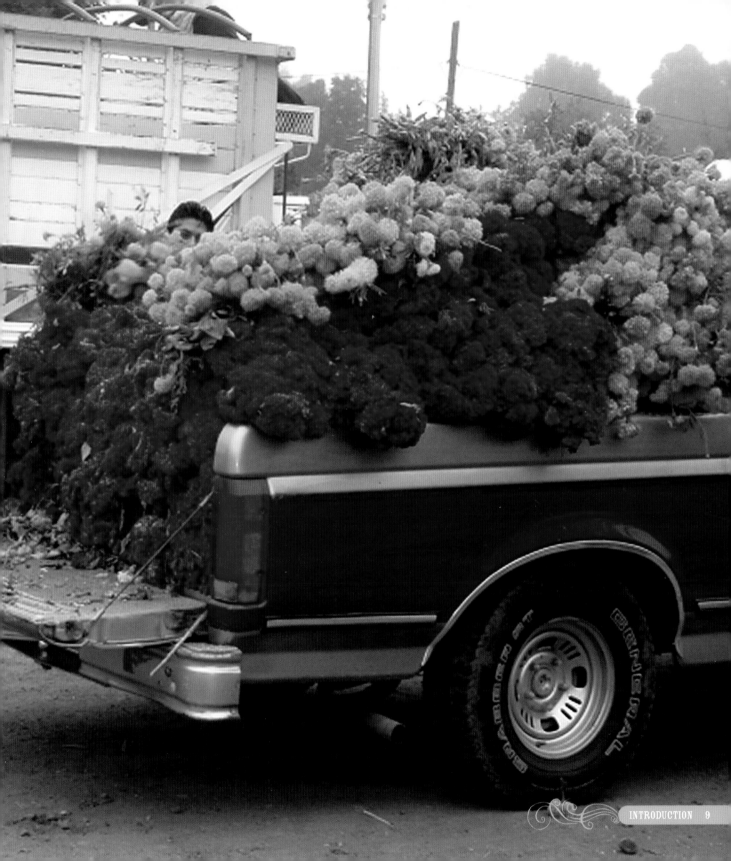

indigenous populations such as Oaxaca and Michoacán. Many elaborate preparations are required for the most important holiday of the year, the Day of the Dead. It may seem strange to those from other cultures that a festival dedicated to the dead should be a joyous occasion, but Day of the Dead is exactly that—it is a celebration of welcome for the spirits of the dead, who return each year for a 24-hour period to enjoy the pleasures they once knew in life. Combining reverence for the dead with revelry to make them happy, and even a certain mockery of death itself, Day of the Dead is a vibrant and colorful celebration of life. The holiday has also inspired a rich tradition of popular folk art featuring grinning skulls and dancing skeletons.

The Day of the Dead has roots in both New World and European traditions. The inevitability of death has long been accepted by the native people of Mexico, who incorporated remembrances for the dead in ancient harvest festivals. With the arrival of the Spanish in the 1500s, the Christian tenet of eternal life was introduced.

Over the centuries, the traditions became intermingled. Contemporary Day of the Dead festivities combine aspects of the Catholic feasts of All Saints' Day and All Souls' Day with nature-based traditions from pre-Hispanic times.

The majority of the Day of the Dead festivities occur between the evenings of October 31 and November 2. According to the

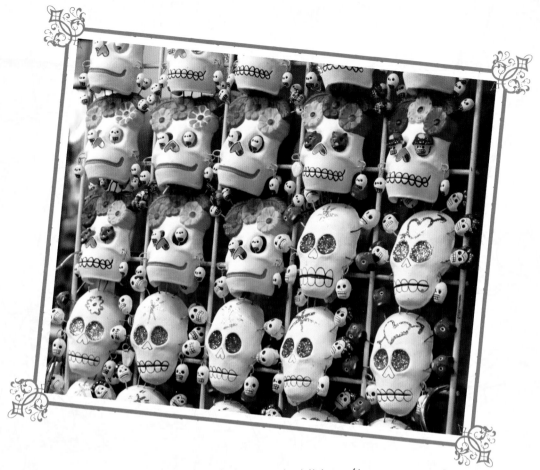

most common tradition, the souls of departed children (*los angelitos*, or the little angels) return to earth first, followed by the souls of adults. In some places, additional days are designated for remembering particular categories of the dead, such as those who have no survivors and those who died in accidents or by violent means.

The obligation to participate in the celebration and make an offering is very deeply felt, especially among the native people, and a vital part of maintaining a good relationship with the dead. Many stories are related about those who became sick, or even died, as a result of not fulfilling their obligations.

Because the Day of the Dead is celebrated at roughly the same time of year as Halloween and the two share some

common roots, Day of the Dead is sometimes referred to as the "Mexican Halloween." However, the focus of the two holidays is quite different. With its emphasis on remembering and honoring the dead, Day of the Dead is in some ways more similar to the American observation of Memorial Day.

As celebrated today, the Day of the Dead is essentially a family time—a time of reunion for both the living and the dead. Those who live far away return to spend the holiday with their families.

Although the details vary from region to region and village to village, the basic premise remains: the spirits of the dead return for a brief period. Their souls are not feared, but greatly anticipated and warmly welcomed. Family members receive the souls first at home, offering food and drink on an altar, or *ofrenda*, and later commune with them beside their graves at all-night vigils.

In addition to delicious feasts prepared in their honor, several other elements are commonly used to attract the souls and help them find their way home. The marigold, or *cempasúchil* (sem-pa-SOO-cheel), with its pungent aroma, is the traditional flower of the dead. The beautiful yellow and orange blossoms are arranged on graves and altars, and children scatter marigold petals to create paths to help guide the spirits. Other traditional flowers for the celebration include the brilliant magenta

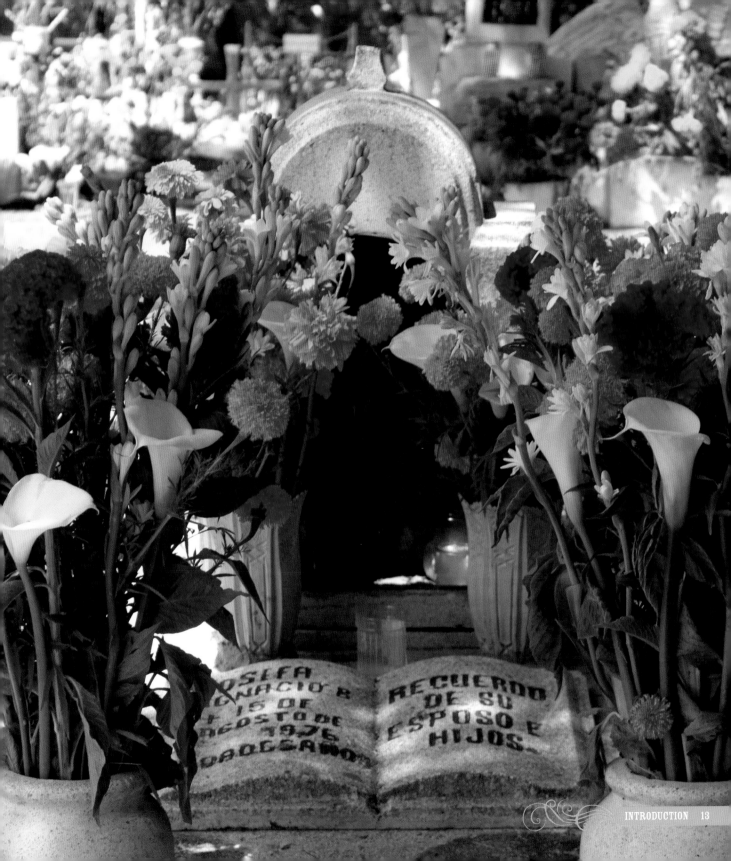

cockscomb and white baby's breath. Gladiolas and carnations are sometimes used to decorate graves as well.

Candles glow softly on *ofrendas* and around the graves, at least one for each soul being honored, and the air is heavy with the strong, distinctive scent of *copal* incense. Made from the resin of the *copal* tree, it, too, is believed to attract the souls of the dead.

Skeleton and skull imagery figures prominently in all aspects of the celebration. Mexicans would rather joke about death than fear it. Those leering skulls and the skeletons with their clattering bones are simply expressions of the Mexican sense of humor and an honest appraisal of human mortality.

The Day of the Dead is a joyous party, hosted by the living, with the dead as celebrated guests of honor. The festivities invite us all to accept death, mock it, and revel in it. And why not? There's certainly no escaping it.

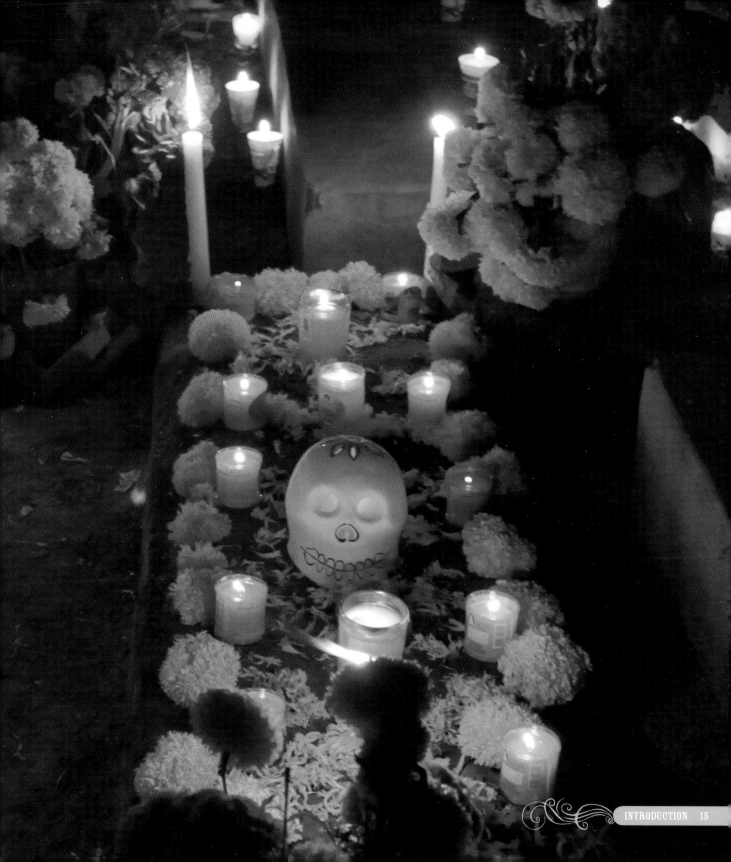

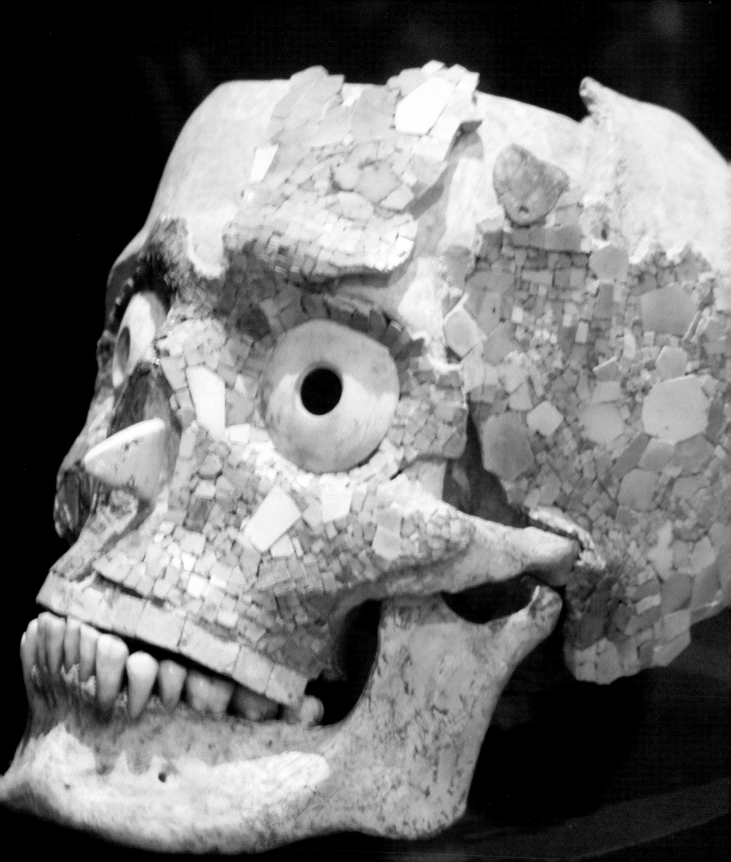

LiFE
From Death

ORiGiNS

W
e come only to sleep, only to dream

It is not true, it is not true that we come to live on this earth

We become as spring weeds, we grow green and open the petals of our hearts

Our body is a plant in flower, it gives flowers and it dies away

I, Netzahualcoyotl, ask: does one really live with roots in this earth?

Not always on this earth, only a little while here

Even jade breaks, just as gold breaks

Even the quetzal plumes fall apart

Not always on this earth, only a little while here.

—NETZAHUALCOYOTL
POET AND RULER OF TEXCOCO

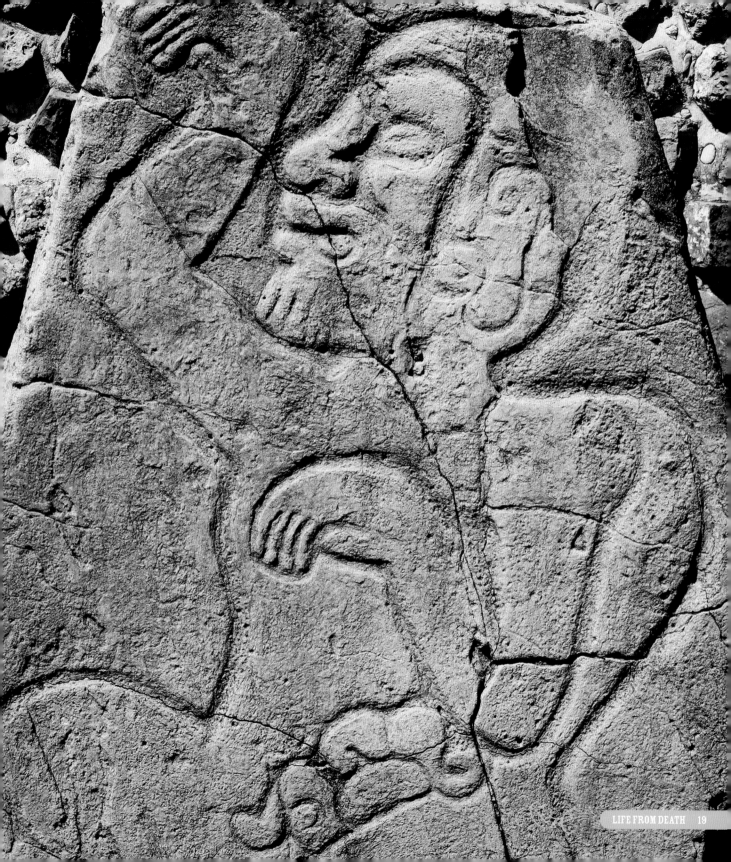

AZTEC DEATH & AFTERLIFE

Life arises out of death. This was perhaps the most important tenet of Aztec cosmology. According to their creation legend, the fifth—and current—world began when the great plumed serpent, Quetzalcoatl, poured his blood over the bones of his ancestors gathered from Mictlán, the home of the dead, to begin the human race.

In all Mesoamerican religions, including the Aztecs', there is a recurring theme of interdependence and interaction between humans and their gods. The Aztecs' well-known practice of human sacrifice provides a graphic example of this relationship. Victims' still-beating hearts were cut from their bodies and offered to the gods in an effort to appease them and ensure an abundant harvest.

Our current knowledge of the Aztec gods and their beliefs concerning death and the afterlife comes from the archeological record, pre-Hispanic codices (painted screen-fold books), and manuscripts recorded by early Spanish chroniclers. Belief in an afterlife was present from the earliest times throughout Mesoamerica, as evidenced by the presence of grave goods, items buried with the deceased for use in the next life.

But just as the price of life for the Aztecs was believed to

Aztec warriors who died in battle ascended to the highest level of the heavens, where, as hummingbirds and butterflies, they accompanied the sun god on his daily journey.

be death, which they achieved through their sacrificial victims, the price of death was life. Life was temporary and fleeting—no more than a dream on the way to death. The Aztecs feared the uncertainty of life more than they feared death. Death provided a release from earthly burdens, and the dead went to a heaven that was determined not by how they lived but how they died.

The Aztecs believed there were thirteen layers of heavens above the earth, and nine levels of an underworld below it. Aztec warriors who died in battle ascended to the highest level of the heavens, where, as hummingbirds and butterflies, they accompanied the sun god on his daily journey. Women who died in childbirth flew with them. Those who died in ways connected with water played joyfully in a paradise of eternal spring, and infants went to the Nursing Tree, which dripped milk for their sustenance. All others went to the lowest level of the under-world, Mictlán.

The god of death, Mictlantecuhtli, was not feared by the Aztecs, but the journey to Mictlán was lengthy and arduous. To get there, a soul had to travel for four years and had many

perils to overcome along the way. As a result, there were four years of corresponding rituals to be performed on earth following a person's death.

Each year in early fall, the Aztecs participated in a festival dedicated to the dead. According to the accounts of early Dominican friars, the celebratory rituals involved a profusion of flowers, feasting, and dancing.

Offerings to the ancestors accompanied these rituals as well. It was believed that the souls of the dead returned to the homes where they had resided. To properly welcome them, relatives provided newly harvested corn and chiles, along with a variety of favorite foods and drinks, such as tamales, tortillas, pumpkins, quail, and rabbit. The residents of the home would keep vigil during the night, remaining in a squatting position and not daring to lift their eyes for fear the visiting souls would punish them for displaying a lack of respect.

OTHER TRADITIONS FROM AROUND THE WORLD

The Aztecs were not alone in observing such rituals. In a world dominated by nature and the natural rhythms of the sun and moon, there was a logical correspondence between the agricultural cycle and the human cycle of life. Harvest festivals,

Harvest festivals, held during the fall of the year by ancient peoples worldwide, frequently incorporated a remembrance of the dead.

held during the fall of the year by ancient peoples worldwide, frequently incorporated a remembrance of the dead.

The ancient Egyptians commemorated the death of Osiris, the god of life, death, and grain, on the seventeenth day of the month of Athyr—our November. According to tradition, the dead were believed to revisit their homes on this night, where people received them with food and lamps to light their way. When the Romans inherited the concept, Bacchus, the Roman god of life and renewal took the place of Osiris.

The Celtic holiday of Samhain was a time to give thanks for the harvest of the summer and to ask a blessing for the coming months. But the ancient Celts saw Samhain as a very spiritual time as well.

Because October 31 falls midway between the autumnal equinox and the winter solstice, these ancient people, with their reliance on astronomy, thought it was a very powerful time for magic and communion with the spirits. The veil between the worlds of the living and the dead was believed to be thinnest on this day, so the dead were invited to return to feast with their loved ones. Celtic customs included such things as placing food out for dead ancestors and performing rituals to communicate with

those who had passed over. Young people would put on strange disguises and roam about, pretending to be the returning dead or spirits from the other world. Many of these Celtic traditions form the roots of contemporary American Halloween festivities.

CORTÉS AND CHRISTIANITY

Present-day Mexican religious practices meld traditions gleaned from both traditional native religions and the Christianity introduced in the sixteenth century by European conquerors. The traditional Aztec way of life was forever altered in 1519 with the arrival of Hernán Cortés and the Spanish. Their goal was not only to conquer the New World, and appropriate the native gold and treasures, but to assure their own place in heaven by converting the inhabitants to Catholicism.

Upon arriving in the Aztec center of Tenochtitlan, Cortés immediately attempted to convert the great Aztec ruler Montezuma II, in hopes that his people would follow. Although he resisted initially, Montezuma eventually conceded that it was possible the Aztecs were mistaken in their beliefs. He decided that, as a more recent arrival, Cortés might be right, so Montezuma allowed a Christian cross to be erected and an image of the Virgin Mary placed at the Great Temple of Tenochtitlan.

A fortuitous case of mistaken identity may have played a role as well. While the most common depiction of the great Aztec deity Quetzalcoatl was as a plumed or feathered serpent, he was also sometimes portrayed as a light-skinned and bearded man. According to one version of the legend, Quetzalcoatl sailed off on a raft into the Gulf of Mexico, vowing to return one day. When Cortés and his men arrived by sea in their great ships, Montezuma and the Aztecs may have believed he was the returning Quetzalcoatl.

Montezuma realized too late his mistake in trusting the new-comers, and the conquest was accomplished relatively quickly. However, the secondary goal of converting the population to Catholicism remained. Because of the lack of a common language, the Aztecs misunderstood many of the Christian rituals, and reinterpreted them in terms of their own beliefs and practices. The Catholic friars eventually discovered many concepts and rituals that were similar to those of the Christian church and capitalized on them with the intent of making Christianity more acceptable to the native population.

In later years, the Indians appear to have made a conscious effort to incorporate remnants of their native religion into Christian practice, placing Catholic saints and pagan gods side-by-side on home altars. The Catholic friars encouraged

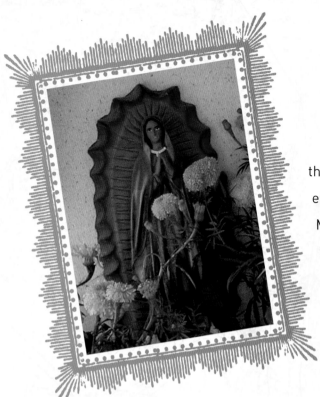

this, explaining aspects of Christianity by equating them with similar native concepts. Many Catholic saints ultimately replaced the gods of the polytheistic religion of pre-Hispanic times: Quetzalcoatl became St. Thomas the Apostle, for instance, and St. John the Baptist replaced the rain god Tlaloc. The best-documented example is the identification of the Virgin Mary with the goddess Tonantzín. Likewise, when a feast day in the Catholic calendar occurred around the same time as an Aztec festival, the traditions were often combined.

The Day of the Dead is a wonderful example of this synthesis of belief and tradition. When the Spanish arrived in the New World, they also brought folk practices from early sixteenth-century Spain. Pagan traditions still existed in some areas of Spain. For example, in addition to the traditional Catholic masses that marked the celebration of All Saints' Day and All Souls' Day, visits to cemeteries were common. People decorated the graves with flowers and brought oil lamps and candles for illumination. Feasting was commonly associated with

the commemoration of the dead in pagan customs and rituals, and many believed that the dead would return to earth to partake of offerings of food and wine. These customs were readily accepted in Mexico, as similar practices had been important aspects of pre-Hispanic ritual.

With the European conquest of Mexico, different mourning rituals and concepts were introduced. The idea of heaven and hell added a new dimension to Mictlán, and the Christian celebrations of All Saints' Day and All Souls' Day merged with pre-Hispanic harvest rites. But even though the indigenous beliefs changed and evolved over time, the ritual of the offering to the ancestors remains intact, and the celebration of the Day of the Dead continues to reflect both thanksgiving for the abundance of life and a profound respect for the dead.

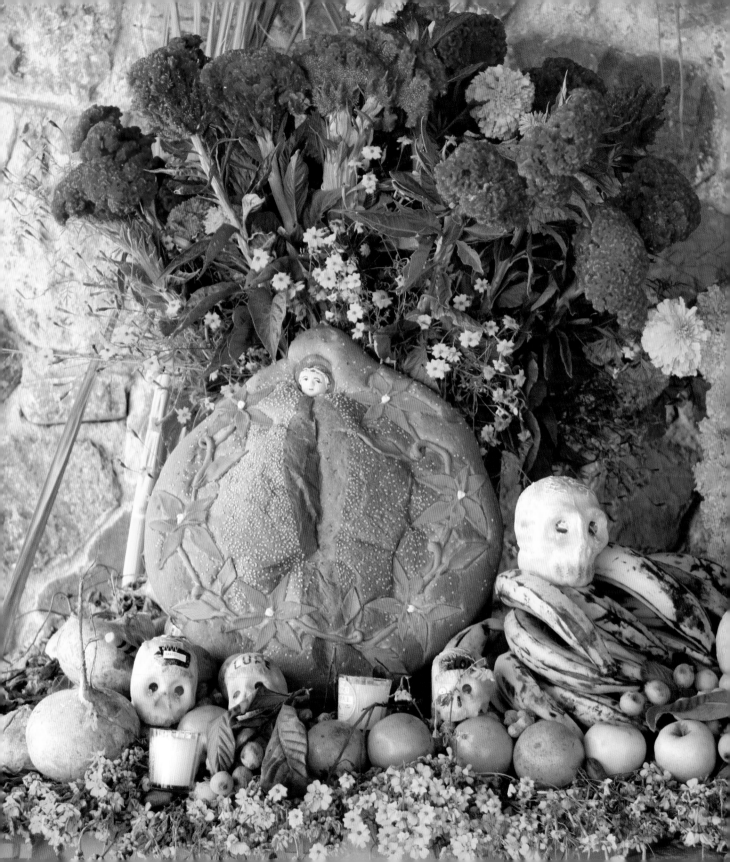

FEASTING and REVELRY

CELEBRATING WITH THE SPIRITS

Fiestas are our sole luxury. . . .
What is important is to go out, open up a way,
get drunk on noise, people, colors.
Mexico is in fiesta.

—OCTAVIO PAZ
THE LABYRINTH OF SOLITUDE

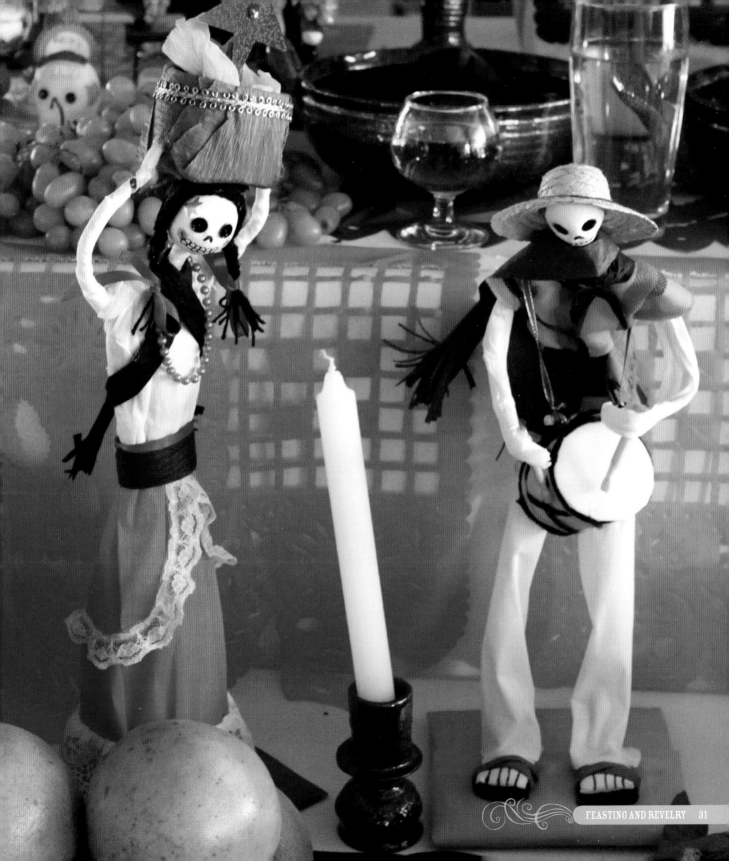

The celebration of the Day of the Dead is expressed through a variety of traditions. Family members work together to construct an *ofrenda*, where returning souls of the dead will first be met and welcomed. Later, adults and children go to the cemetery for an all-night vigil. Far-flung family members—sons and daughters, aunts, uncles, and cousins—come home to spend the holiday with their families. There is much feasting, as special foods are prepared to nourish both the living and the dead. In some areas, the festivities conclude with a *comparsa*, in which masked participants known as mummers parade and dance through the streets, entertaining the spectators and encouraging the return of any souls who might still be lingering.

With so much to do in the days and weeks leading up to the celebration, the market becomes a hub of activity. Impromptu flower markets spring up as well, and flowers arrive by the truckload.

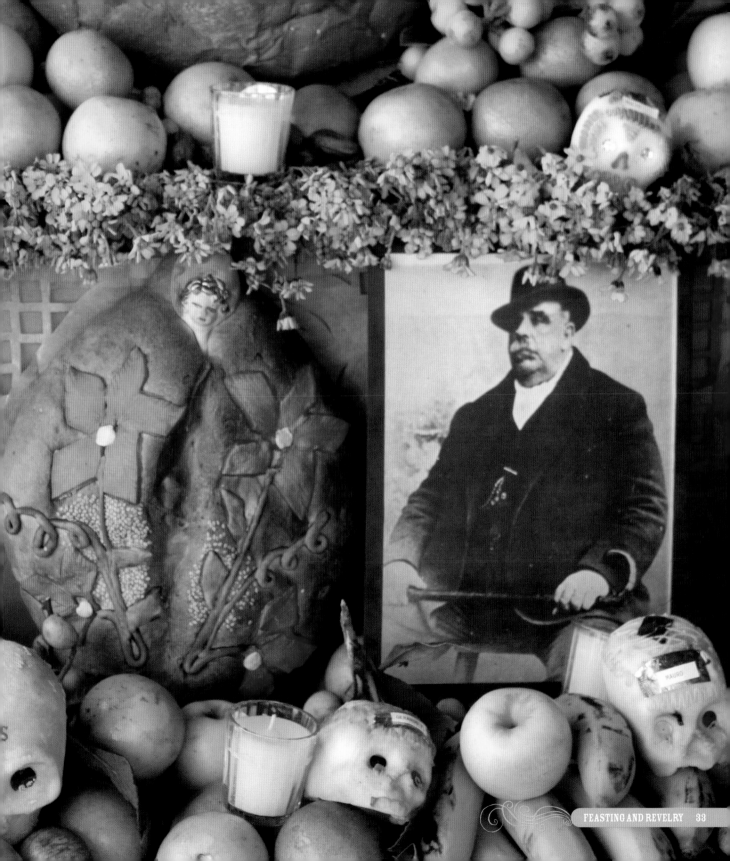

In addition to bright bundles of flowers, chunks of fragrant *copal,* along with traditional three-legged ceramic burners, are offered for sale. The *copal* is used both on the *ofrendas* and at the cemeteries to welcome and guide the returning souls. Bakeries offer *pan de muerto*, a special orange- or anise-flavored bread. Baked in the shapes of skulls, bones, and skeletons, it is available only at this time of year.

To decorate *ofrendas*, vendors present row upon row of colorfully decorated sugar skulls ranging in size from tiny to nearly life-sized. Chocolate skulls are also popular. Skeleton figures made of wire, papier-mâché, or wood depict people from all walks of life: office workers at their computers, police officers, fancy top-hatted men, and elegant women. The bridal couple is an ever-present theme, symbolizing a love that will last for eternity. Bright tissue paper banners of *papel picado*, or "punched paper," bear designs of skulls and skeletons as well, and are often hung in front of or above the *ofrendas*.

This is the time to make all the complicated and time-consuming dishes that are reserved for special occasions. Great mounds of *mole* paste, used to make the traditional chicken in

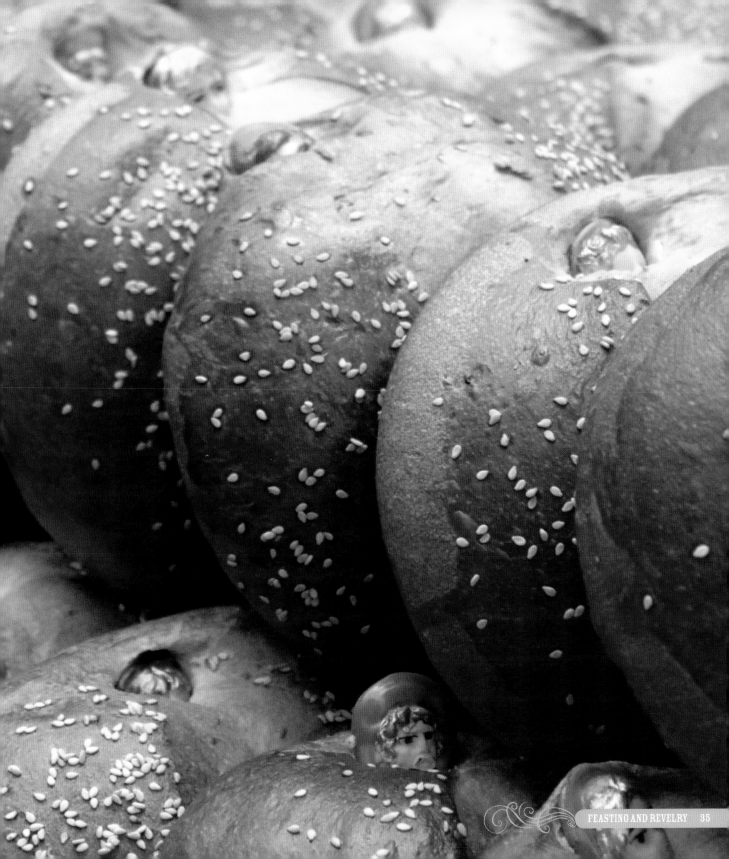

AS the preparations Continue and the time for the arrival of the spirits grows closer, the level of excitement increases. mexico's most important holiday Celebration is about to begin. . . .

mole, are featured prominently in market stalls. Vendors also sell a variety of chiles and *hojas* (corn husks or banana leaves) for making tamales.

As the preparations continue and the time for the arrival of the spirits grows closer, the level of excitement increases. Mexico's most important holiday celebration is about to begin. . . .

THE OFRENDA

Sometime before October 31, family members work together to construct and decorate a home *ofrenda*, a memorial altar where the returning spirits of deceased family members are first welcomed. The *ofrenda* is one of the most important aspects of the Day of the Dead celebration. It usually consists of a table placed in front of a background—generally an arch or wooden frame—that has been lavishly decorated with marigolds and other flowers, as well as fruits and vegetables.

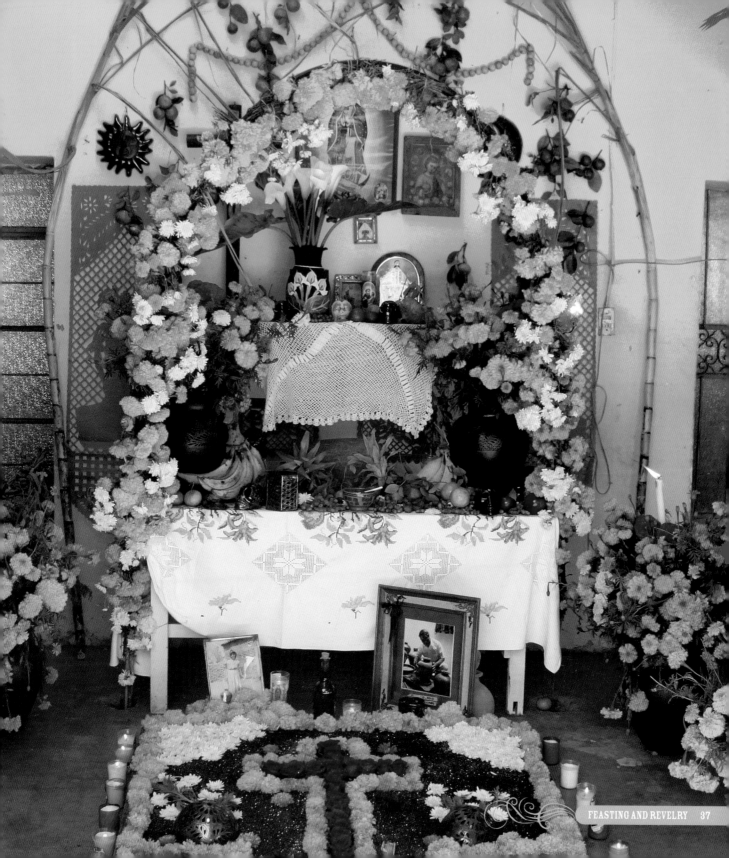

The table is covered with an attractive cloth or other decorative features. In some areas, it is customary to construct the *ofrenda* with multiple levels, which are said to represent either the pyramids of pre-Hispanic times or the stages of life.

There are certain traditional elements common to most *ofrendas*, but each is a unique testament to the creativity of its makers. There are usually basic items that represent the four elements: water, fire, earth, and wind. The returning souls are expected to be thirsty after their long journeys, so a glass of water is provided. Fire is represented by candles, at least one for each person being honored. A wide variety of fruits and vegetables symbolize the bounty of the earth. And light tissue paper banners of *papel picado* flutter in the breeze either above or in front of the table, representing the wind. Often a small dish of salt is added to purify the air. Most also contain personal items that belonged to the person being honored, as well as the skull and skeleton toys, candy, and folk art that are prevalent in all aspects of Day of the Dead festivities.

Loaves of *pan de muerto* and large vases filled with flowers add color and interest. *Copal* is burned in ceramic vessels to

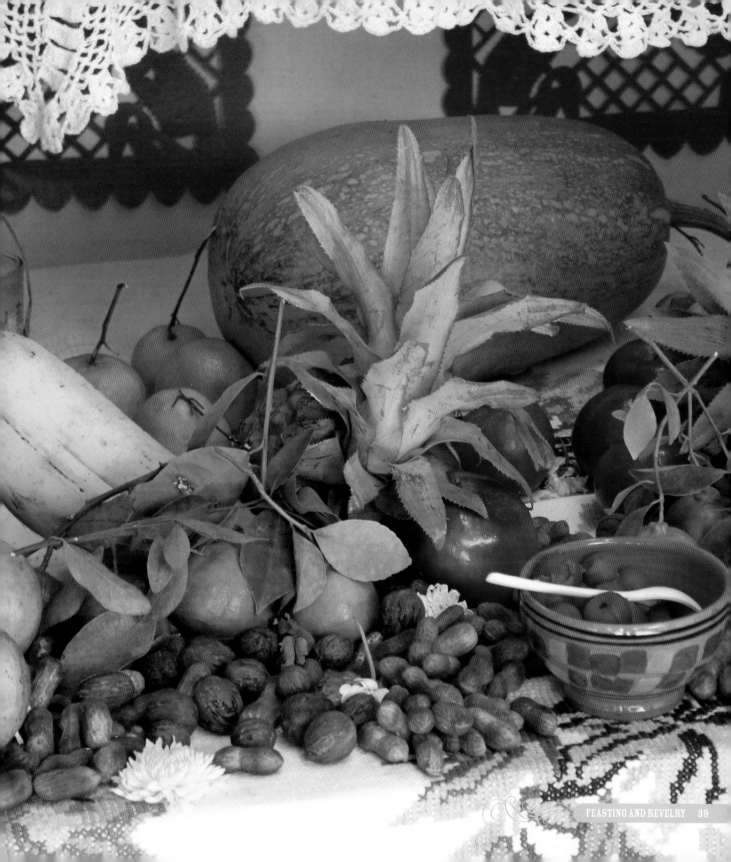

attract the souls of the dead. Flower petals are sometimes spread in paths leading from the street to the *ofrenda* to help guide the spirits.

Framed photographs of those being honored are placed on the *ofrenda*, along with figures or pictures of saints, a virgin, or Christ. Personal items and clothing that belonged to the deceased, such as pieces of jewelry, an embroidered cloth, a wristwatch, a hat, or a belt, also have a place on the *ofrenda*, in addition to favorite foods and beverages that they enjoyed in life. Plates of tamales or chicken in *mole,* sweets, especially *dulce de calabaza* (candied pumpkin) and *ates* (fruit pastes), and bottles of beer, tequila, or mescal are all common offerings. Skulls and skeletons are featured prominently, and frequently irreverently, on most *ofrendas*, including sugar skulls with brightly colored icing and foil decorations, papier-mâché skeletons, and more. The inherent message in this imagery is that the friendship or love that was shared on earth is so strong that it transcends death.

There are also regional variations in *ofrendas*. Dried fish may be featured in villages close to the coast, while elsewhere

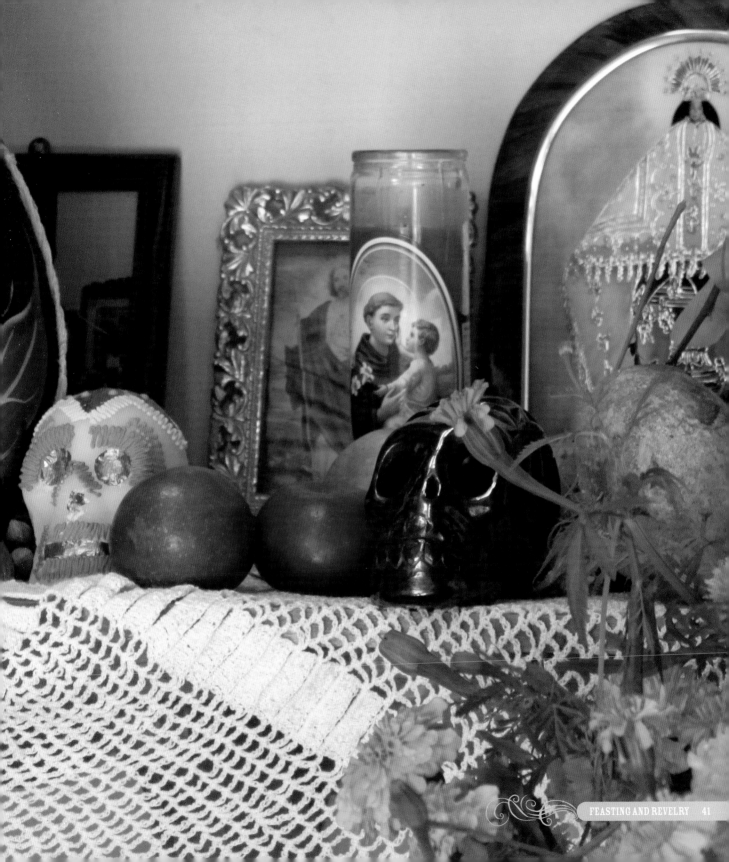

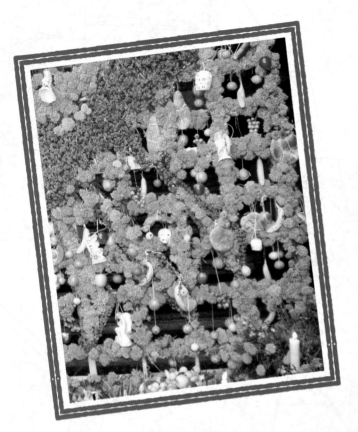

fruits and vegetables native to that region will be found. In Oaxaca *ofrendas* usually have an arch behind the table, while those in Michoacán utilize a wooden frame.

There are socioeconomic variations as well. In poor homes and villages the offerings may be minimal, maybe just a few tortillas and fruits from a nearby tree, while in wealthier homes there will be large plates of food, full bottles of liquor, and even gifts purchased for the occasion.

In many communities, an altar will be constructed in the central plaza or at the church in honor of those who have no one left to honor them—particularly in communities where many of the young people have left to work in the United States. Other

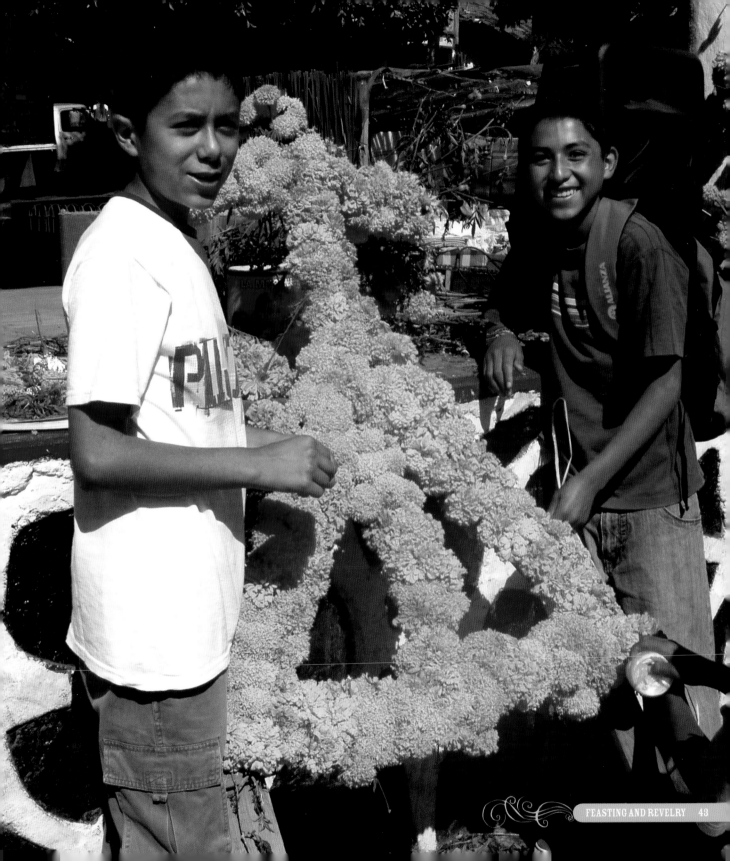

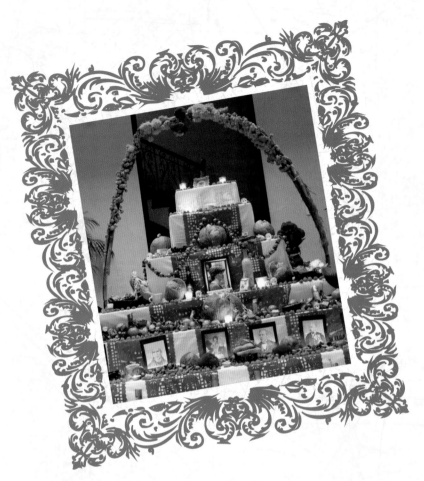

community altars may reflect specific social problems, such as drug abuse or AIDS. School or community *ofrenda* competitions are common, with awards given for the most beautiful and creative. Sometimes museums will host indigenous groups (particularly those who live far from population centers) to demonstrate their specific variations on the celebration.

The offerings on the *ofrendas* are always arranged with an eye for aesthetics. While the components are similar, each *ofrenda* reflects the creative talents of its makers, as well as being a moving memorial to the deceased.

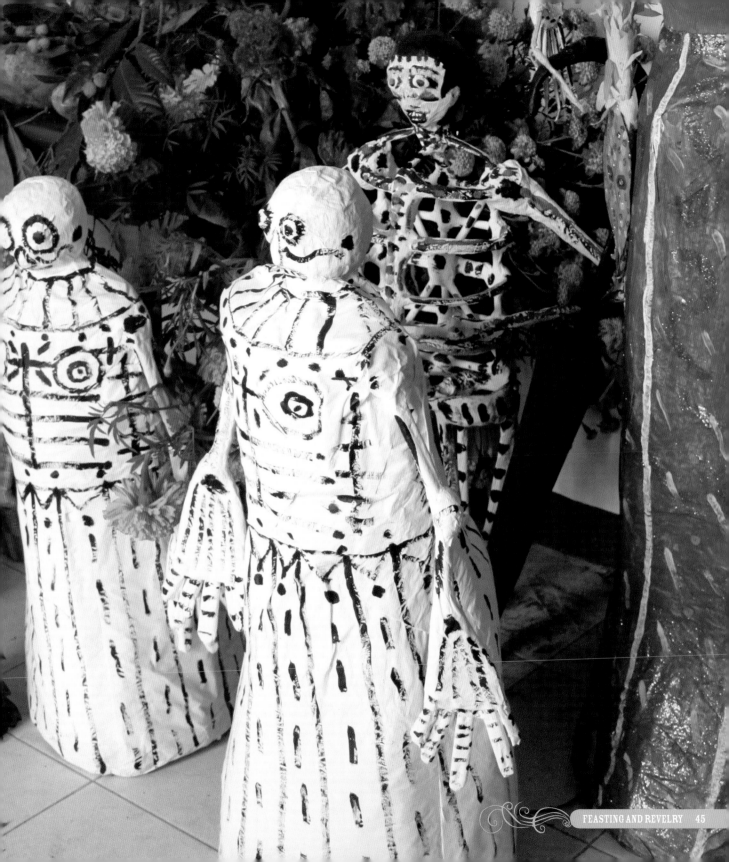

SPECIAL FOODS AND SWEETS

From the brightly iced sugar skulls to simmering pots of spicy *mole*, foods and feasting play an important role in Day of the Dead celebrations. Dishes are prepared with many complicated ingredients and much love, with the intention of nourishing both the living and the dead.

Sugar Skulls and Confectionery

Sugar skulls are one of the most festive icons of the Day of the Dead celebration. Sugar art dates back to the colonial period in

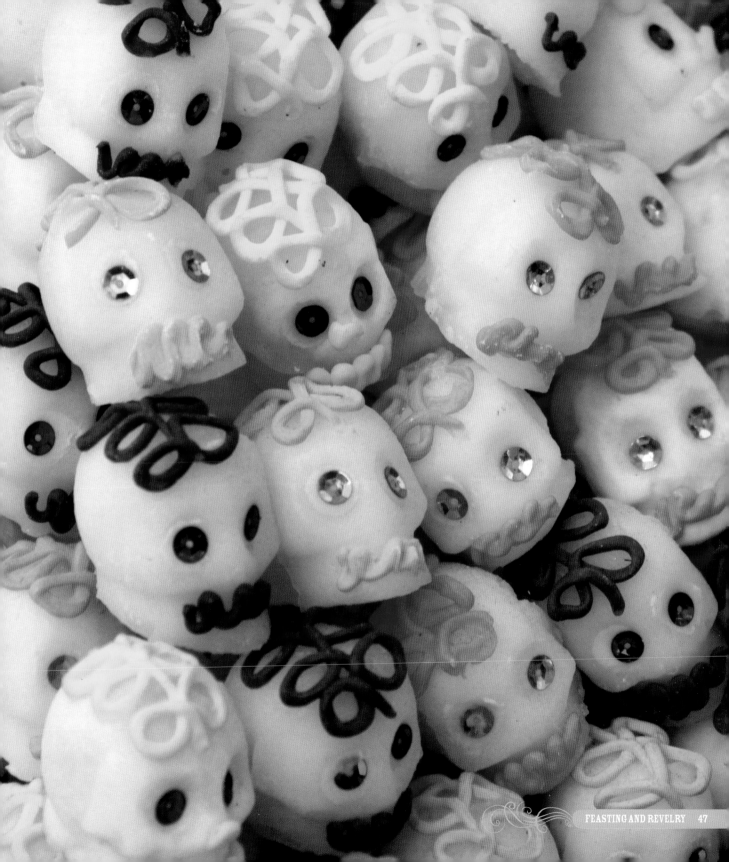

Mexico. Too poor to buy fancy imported European church decorations, but with an abundance of sugar, the faithful learned to make sugar figures such as angels and lambs for religious festivals.

Skulls made of sugar came into popular use for the celebration of the Day of the Dead. Traditionally, the skulls represented a departed soul, with the name of the person being honored written on the forehead. The skulls were placed on home *ofrendas* or gravestones to honor that soul's return. The skulls have also become popular gifts. Like valentines, sugar skulls are exchanged by friends and sweethearts as a token of an affection and love that will transcend death.

To create the skulls, artisans boil sugar and pour it into clay molds. Once the sugar has cooled and hardened, they remove the skulls from the molds and decorate them with colorful icing and bits of foil. Other types of sugar art are created as well, such as coffins with pull strings to raise the corpses from

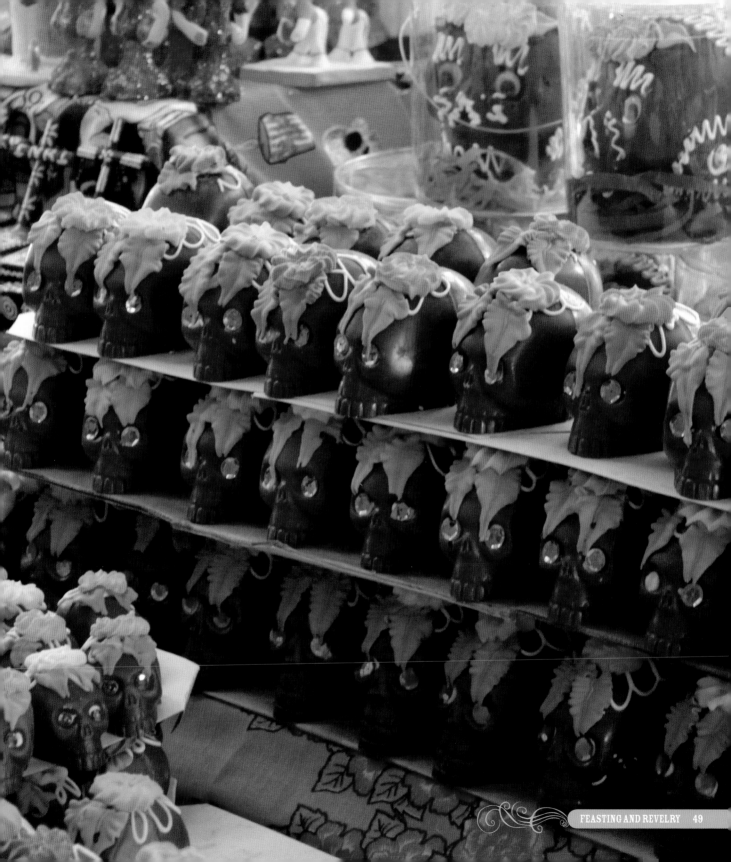

the dead. Hand-molded and decorated chocolate skulls are popular, too, as are skulls made of amaranth seed.

The annual *Feria del Alfeñique* in Toluca, Mexico celebrates the tradition of artisanal sugar. Here, artists who have worked in the medium for generations have an opportunity to show off their elaborate creations. The sugar art is rarely eaten; the primary purpose of the skulls is to adorn the altars and tombs as a sweet delight for the visiting spirits.

Pan de Muerto

During the Day of the Dead, bakeries and markets feature fanciful loaves of *pan de muerto*, or bread of the dead (sometimes also called *pan de muertos*). This slightly sweet yeast bread is flavored with orange or anise and baked in the shapes of skulls, crossbones, and skeletons. *Pan de muerto* is used to decorate *ofrendas* and graves, as well as being a special treat for the living. Traditionally, the loaves are round, with a central raised knob of dough representing the skull and crossbone-shaped decorations radiating from the central knob. The circular shape is said to represent the circle of life.

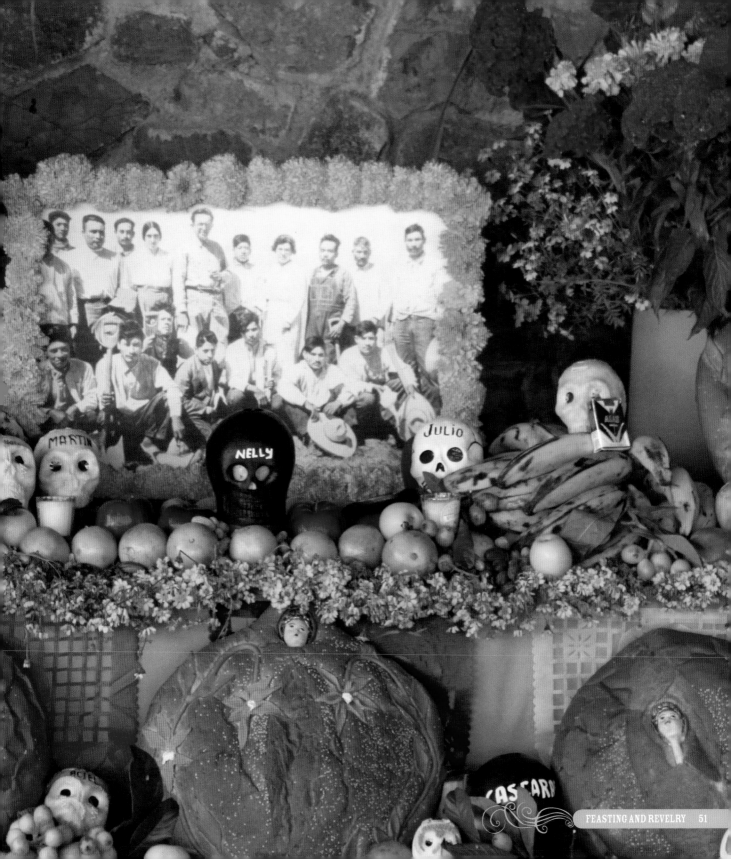

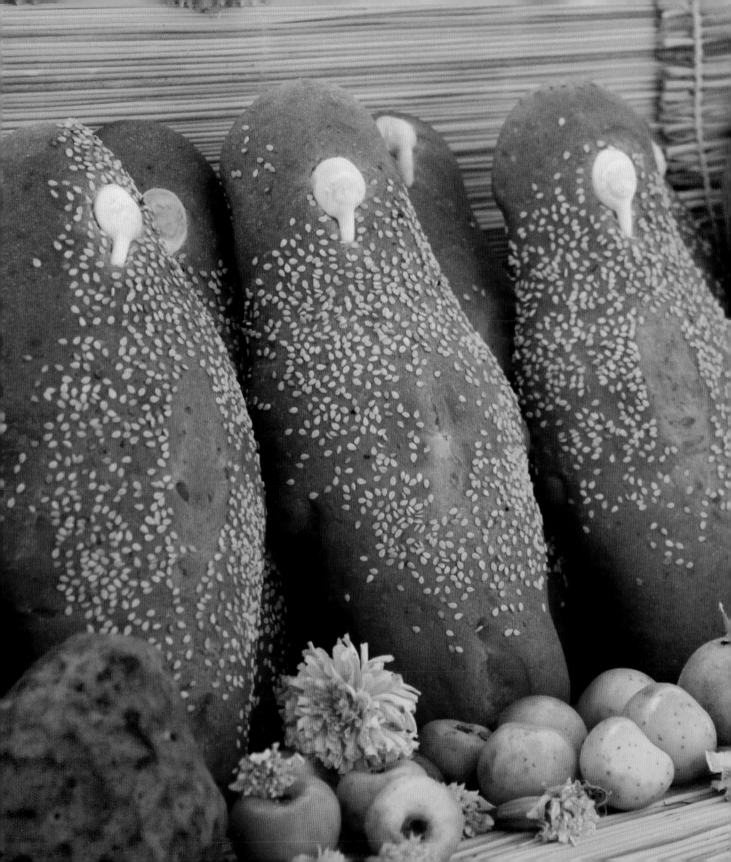

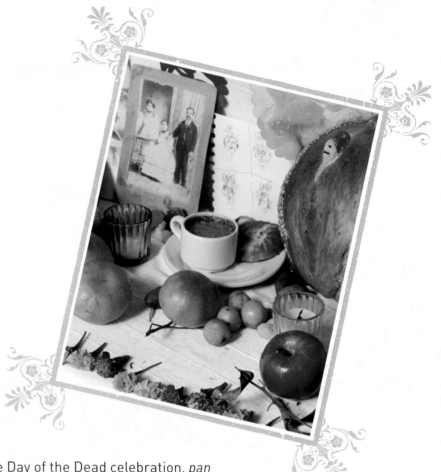

As with other aspects of the Day of the Dead celebration, *pan de muerto* can vary based on region and personal taste. The bread is sometimes baked in the shape of humans or animals. In Oaxaca, *pan de muerto* is the same bread baked year-round, but with the addition of decorations. It is often accompanied by a cup of delicious Oaxacan chocolate, and it is common to tear off pieces of the bread and dunk them in the hot chocolate. In the state of Hidalgo, the bread is usually formed in the shape of human figures or hands and sprinkled with red sugar. This variation is based on the Mexica tradition of covering the bodies of important figures in red dust when they were buried. *Pan de muerto* in Mexico City is shaped like a funeral mound, with a

few bumpy protrusions representing the skull and limbs of the deceased poking out.

A Feast Fit for the Dead

As the time for the Day of the Dead festivities approaches, women begin preparing the feast. Spicy dishes and those requiring many ingredients, such as *mole* and tamales, are common offerings. It is important to give the spirits the things they loved in life, and for the families to demonstrate their affection for their departed relatives by preparing complicated dishes with great love and care.

The markets are hectic as people shop for chiles and other ingredients for the *mole,* as well as large clay *ollas,* or pots, to cook it in. Depending on the region, tamales are wrapped in either corn husks or banana leaves. Vendors in the market sit amongst small mountains of these *hojas* that they have brought to sell. *Café de la olla*, a special sweet coffee flavored with cinnamon and cooked in the clay pots, helps keep the family members warm and awake during the all-night vigil.

The frenzy of activity continues at the chocolate factory. Cooks not content to purchase the standard *mole* paste sold in

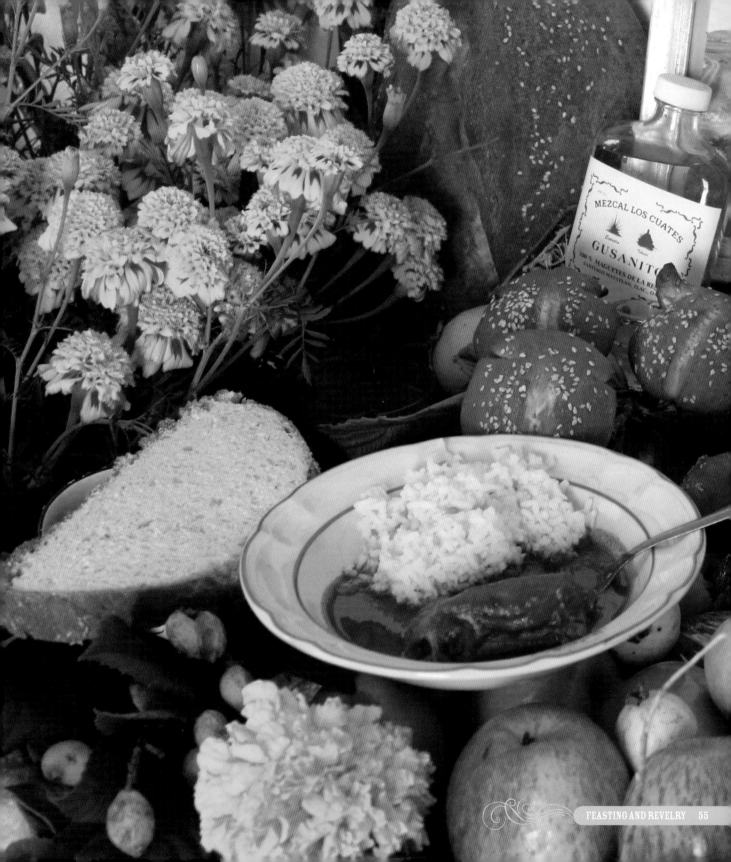

the markets have chocolate ground with sugar, almond, cinnamon, and vanilla for traditional family recipes handed down through the generations. Others purchase large chocolate tablets to make hot chocolate. *Atole*, a flavored corn paste beverage that both warms and nourishes, is also popular. When flavored with chocolate, it is called *champurrado*.

Back at home, the cooking begins in earnest. Because of the large quantity of food required, cooking is often done over an open fire in the patio or courtyard. With more family members arriving all the time, there are many mouths to feed, but also more hands to help. Long hours of cooking give the women a chance to catch up on news and gossip; men do the same, often over a beer or glass of mescal.

As the time for the celebration grows near, the homes are warm and fragrant. *Mole* simmers in pots and tamales steam. A seemingly never-ending stream of tortillas, either corn or flour depending on regional preferences, is made and consumed. Day by day the offerings on the altar grow, and when the appointed night arrives, the feast is taken to the cemetery to honor the deceased and share with family and friends.

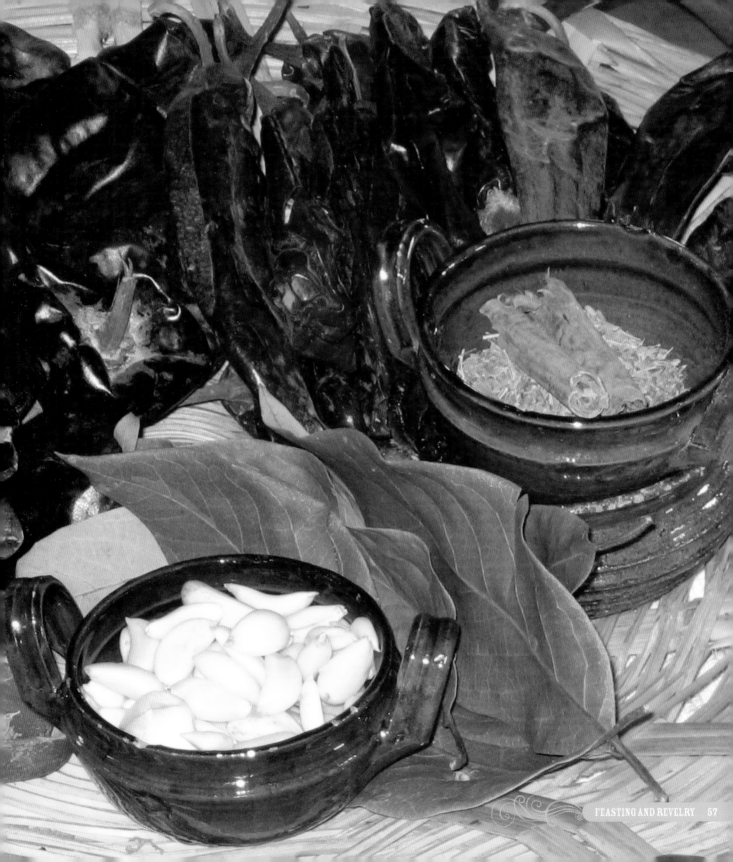

CEMETERY VIGILS

After the souls have been greeted and welcomed at the home *ofrenda*, the festivities continue with an all-night vigil at the cemetery. The logistics vary by region and who is being honored. In some areas, a special night is observed for children (*los angelitos*), or for those who died by violent means.

When the appointed night arrives, the graveyard is ablaze with candlelight, and the scent of marigolds and *copal* fills the air. In some villages, church bells are rung beginning at noon to summon the souls.

Most cemeteries in Mexico do not have caretakers, so it is the responsibility of the family to tend to the plots and to clean and make any needed repairs to the graves. The graves range from simple wooden crosses to elaborate mausoleums. In the days leading up to the vigil, family members work together to cut weeds, repair chipped plaster, replace loose stones, and give the tombs a fresh coat of paint.

Once the graves are clean and in good repair they are decorated. Here again, the marigold figures prominently, albeit with

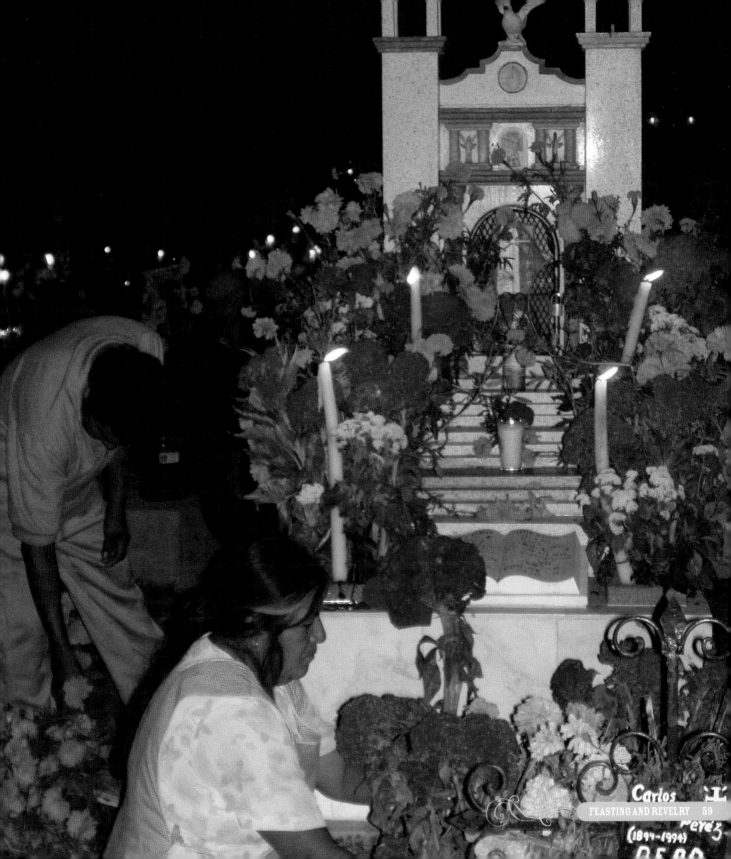

Carlos
(1894-1994)

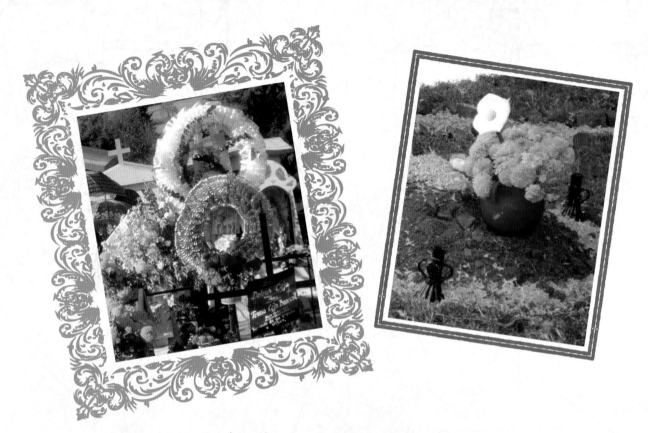

certain regional variations. In Michoacán the graves are built up every year with fresh mounds of mud, which are then blanketed with marigold petals. In other areas the entire blossom is utilized, along with additional flowers, especially pink cockscomb and baby's breath. Sometimes the flowers are put in large vases or coffee cans, or simply placed around or on top of the grave. In more metropolitan areas, colorful *coronas* (floral wreaths) or artificial floral arrangements have become commonplace.

There are variations by cemetery as well. At one small graveyard in Michoacán, long taper candles are used almost exclusively, creating a beautiful and elegant look. In other places, impromptu competitions may spring up, with each family competing to see who can create the most lavish and creative grave

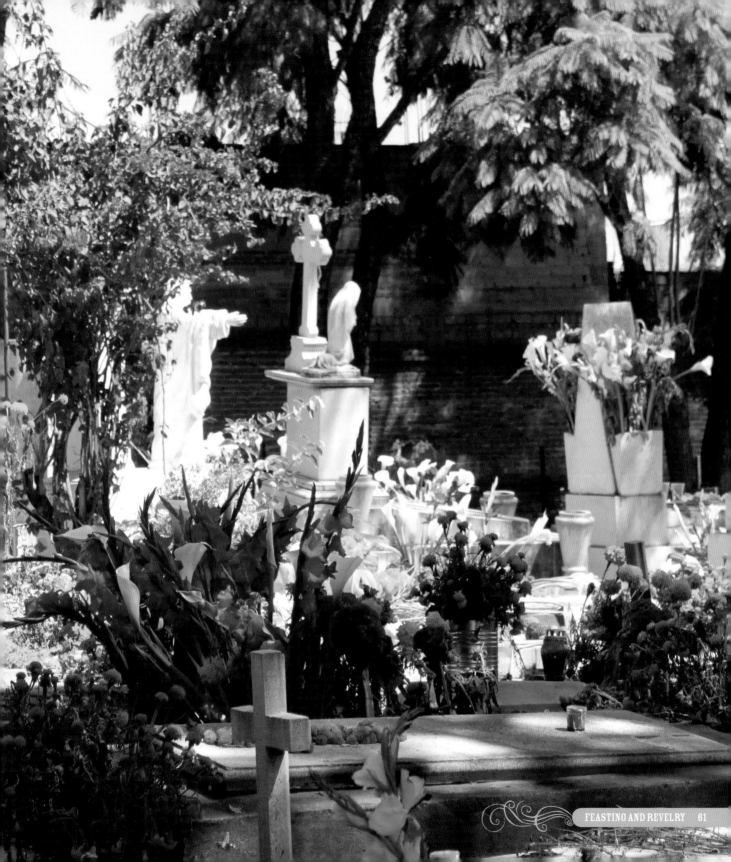

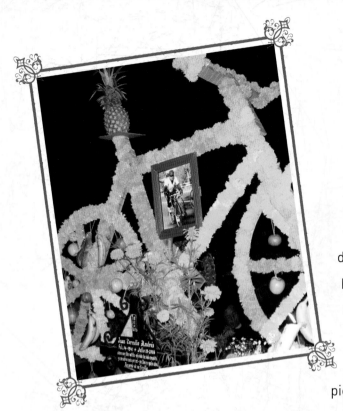

decorations. One memorable grave boasted a full-sized bicycle created entirely of marigolds.

As night falls, families begin arriving at the cemetery with children and picnic baskets in tow. In some places, the local priest presides over an open-air mass as the festivities get underway. Although the outside temperature may be cool, a warm glow emanates from the cemetery. On the fully decorated graves, thousands of candles now illuminate a profusion of flowers.

The souls are not seen, but their presence is felt. The graveside reunions are usually more festive than somber, sometimes accompanied by music and fireworks. Families bring the feast they prepared. The souls are not expected to physically consume the food or beverages, but to absorb the essence of the feast. After a time the living partake of it as well, and the food may be offered to other friends and relatives. Occasionally there is community-wide sharing.

At some graves boom boxes blare, and there is much conversation and laughter. At others, widows sit alone, seemingly

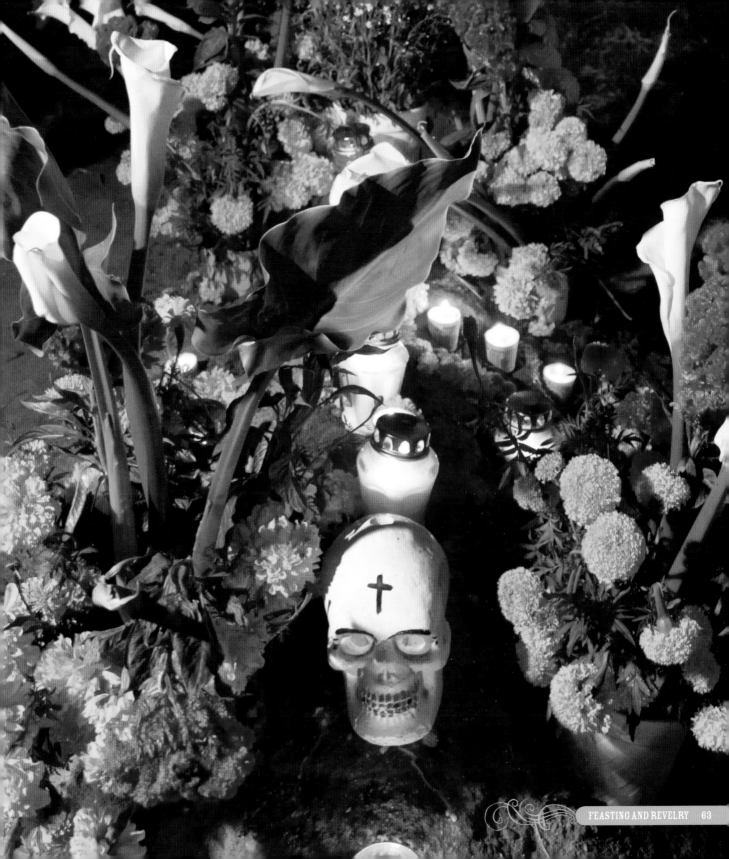

lost in their thoughts. But even at those graves where the mood is more solemn, it is not sad.

Throughout the cemetery, women wrapped in warm shawls, or *rebozos*, nurse babies or tend to pots on small fires beside the graves. Huddled under mounds of blankets, children slumber peacefully on straw mats. The men gather in small groups, chatting and often imbibing a little mescal or tequila. Occasionally someone will take out a guitar and strum a tune. This is a time to enjoy the company of the dead, but also to socialize with the living.

Family members pass the long hours telling stories and remembering good times, comforted by the knowledge that for this one night their loved ones are with them again.

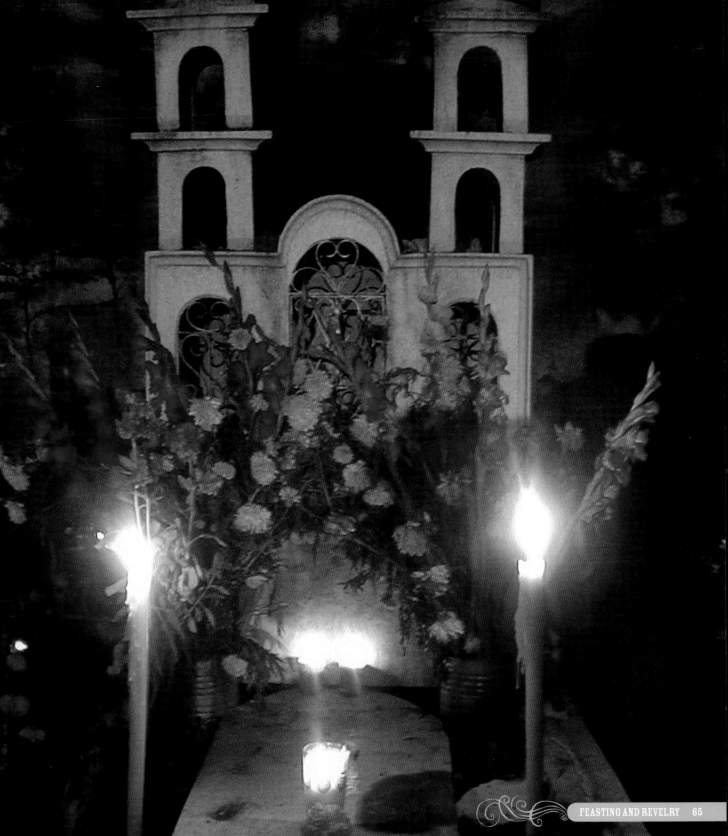

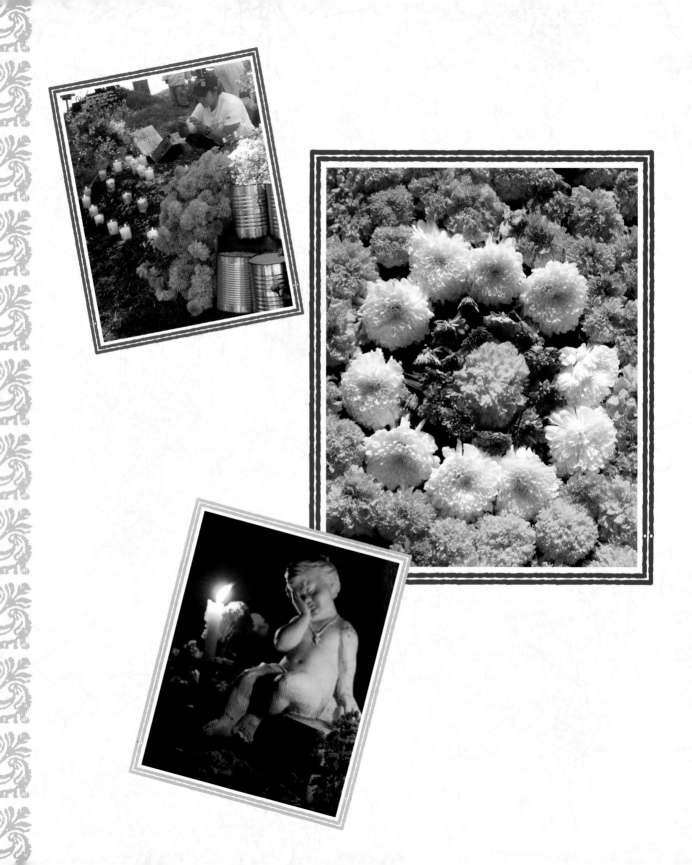

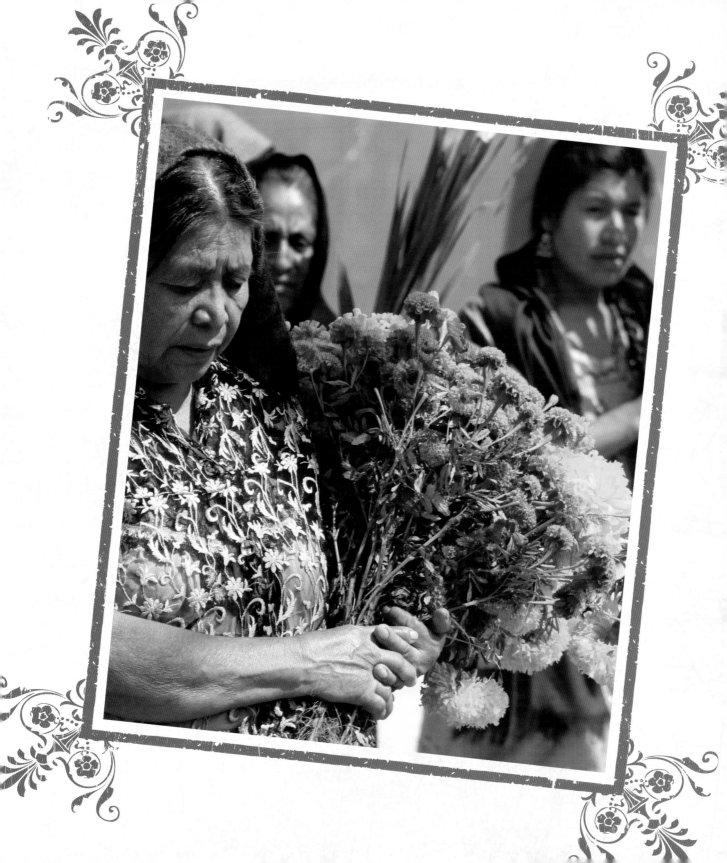

COMPARSAS

Oaxaca is renowned for its vibrant *comparsas*. A *comparsa* is similar to a carnival, with a procession of costumed mummers winding through the streets laughing, singing, dancing, and clowning around. In addition to entertaining the spectators, it is the responsibility of the mummers to shoo away any spirits who may have lingered a little too long.

The performers are usually accompanied by a band and singing minstrels—and often the sound of fireworks in the background. The mummers stop along the way, either where a crowd has gathered or at a private home where someone is willing to give them a little drink and money in exchange for a performance.

Comparsas occur all around Oaxaca City and in some outlying villages, but they are informally organized so it's often difficult to know if or when one might occur. One of the most popular *comparsas* takes place in the village of Etla, usually in the afternoon and evening of November 1, and offers a perfect opportunity for spectators to join in Day of the Dead festivities.

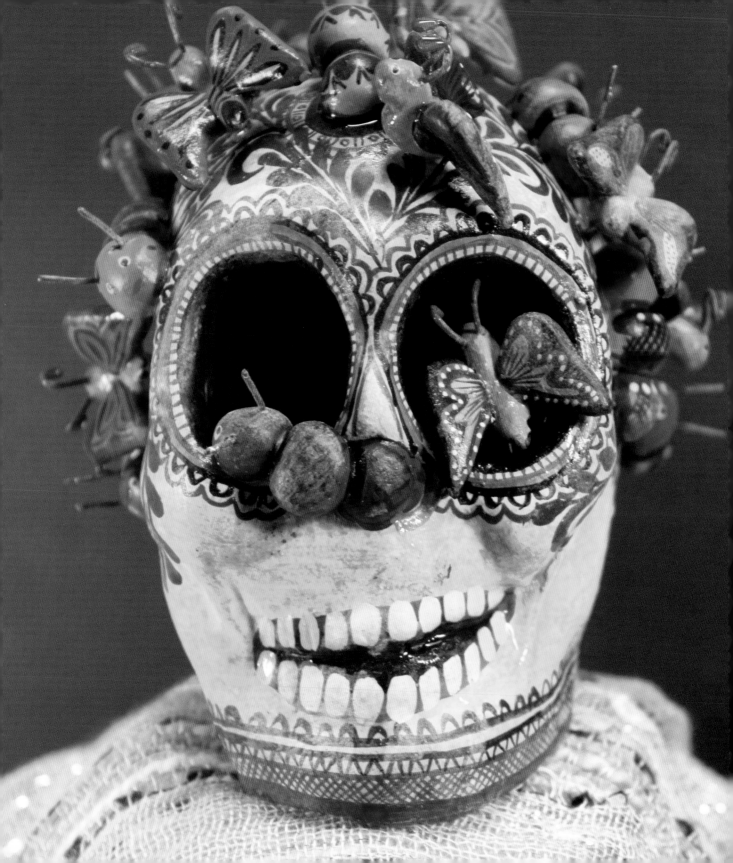

GRINNING SKULLS and Dancing Skeletons

FOLK ART

Death is still the terrible yet amusing entity
that establishes a compromise between memory and a sense of humor,
and between the sense of humor and the irremediable.

—CARLOS MONSIVÁIS

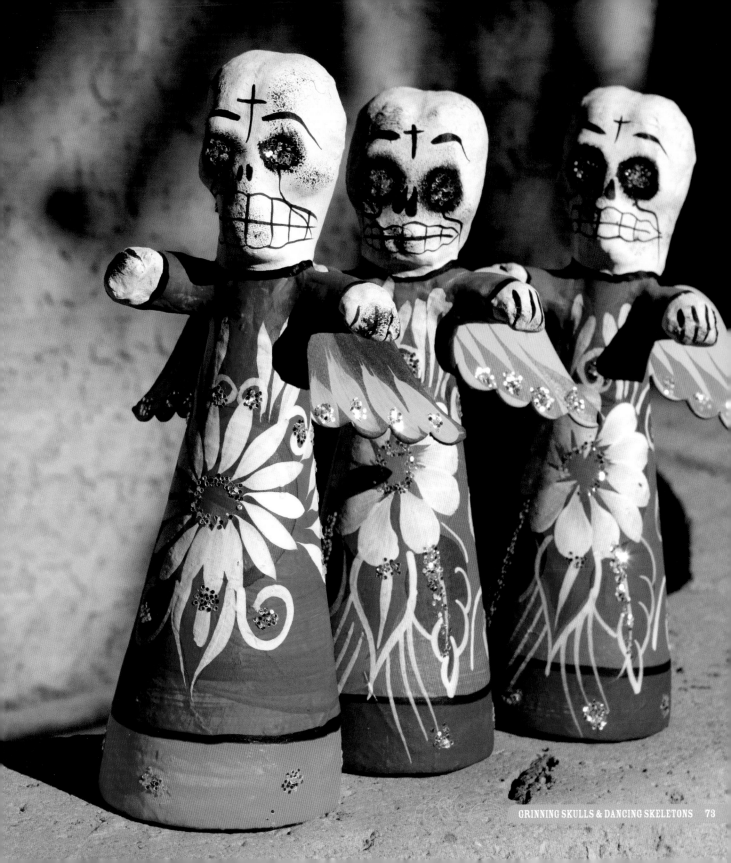

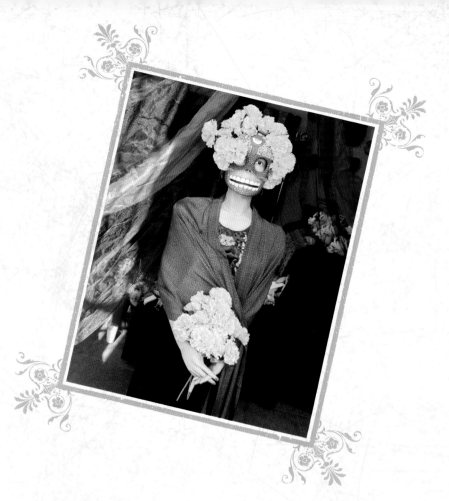

Grinning skeletons wave to the crowds from balconies high above the street. Others, life-sized or even larger, are positioned at the entrances to stores, hotels, and other public buildings. Made of nearly every material imaginable—wood, clay, metal, papier-mâché—they bear no trace of malice as they cheerily greet visitors. Scenes such as this are common during Day of the Dead festivities, and the preponderance of death images is the reason that many not familiar with the celebration may view it as morbid or macabre. But the holiday has inspired a rich folk art tradition; the skulls and skeletons are intended to be humorous and are created in recognition of the fragility of life.

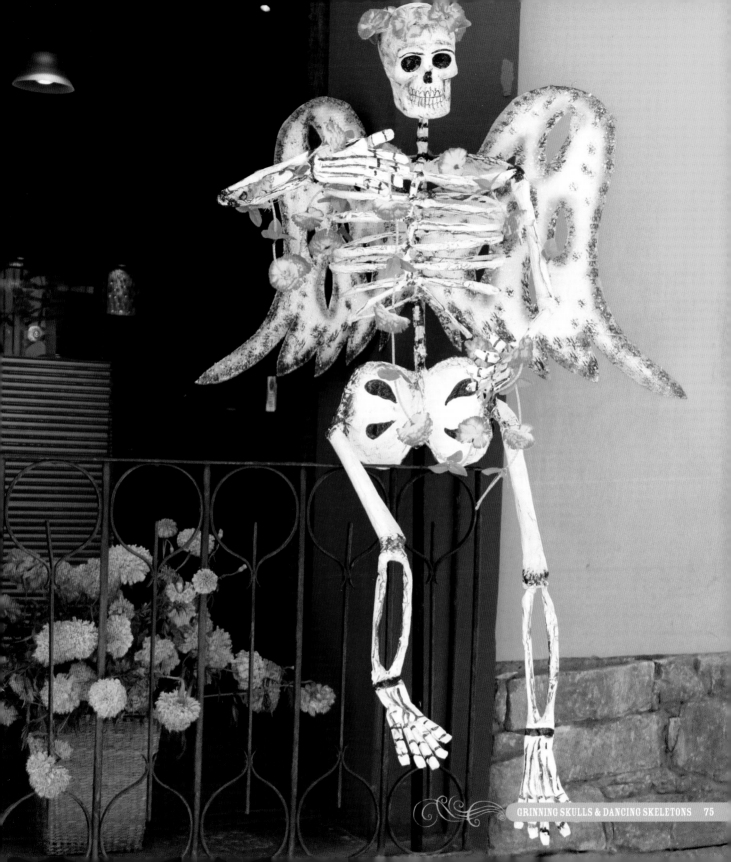

ROOTS iN PRE-HiSPANiC CULTURES

Images representing death are found in numerous examples of pre-Hispanic pottery and carvings. On the Gulf Coast, archaeological sites from the classic period (200–900 CE), such as the ball court at El Tajín, contain carvings of skulls and skeletonized figures. The Maya of southern Mexico and parts of Central America often utilized skulls in architectural decorations. A Oaxacan pottery head from the late classic period expresses the duality of life and death: half the head shows facial features of a living being and the other half a skull. Fewer representations of death are found among the sculptures and frescoes at Teotihuacan, north of present day Mexico City, but a notable exception is a circular stone with representations of a skull

with a protruding tongue carved on both sides. In some cases the death imagery is associated with known sacrificial sites, but not always. And even where sacrifice is shown, it is always associated with symbols for new life.

Examples of death imagery from the classic period are relatively few, however, in comparison with those from civilizations of the post-classic period (900–1520 CE). In all areas—Central Mexico, the Mayan region, and the Gulf Coast—images of death proliferate. Everywhere there are scenes of sacrifice, pottery vessels in the form of skulls and skeletons, and skull racks to display skulls of sacrificial victims. It appears the cycle of death and renewal took on a new urgency during this period.

JOSÉ GUADALUPE POSADA

The work of Mexican illustrator José Guadalupe Posada (1852–1913) has come to be closely associated with the Day of the Dead, and serves as a bridge between the pre-Hispanic imagery and its expression in contemporary folk art. A political cartoonist and printmaker, Posada frequently depicted politicians and other important figures as skeletons in his work. His intention was to poke fun at the wealthy and to remind people that, in death, all souls are equal.

Born in 1852 in Aguascalientes, Posada discovered his talent for art at an early age by copying the artwork he saw on religious cards and small pictures. His long career began in 1871 as a political cartoonist for a local newspaper. After only eleven issues the newspaper closed, reportedly because one of Posada's cartoons had offended a powerful local politician.

Posada eventually moved to Mexico City, where his first regular employment was with *La Patria Ilustrada*, whose editor,

Posada's subject was the great theater of the world of man, At once drama and farce. He was the engraver and chronicler of the daily scene.

—OCTAVIO PAZ

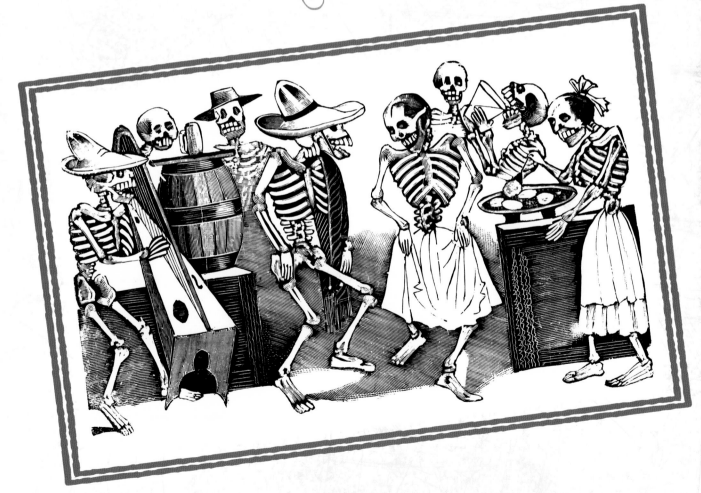

Posada's image of Catrina, an elegant and well-dressed female skeleton wearing a large, fancy hat, is the most popular and well known of the many figures and symbols associated with the Day of the Dead.

Ireneo Paz, was the grandfather of famed writer Octavio Paz. Posada later joined the staff of the publishing firm of Antonio Venegas Arroyo, for which he created a number of book covers and illustrations. Much of his work was also published in sensationalistic broadsides depicting current events. These broadsides communicated important information to the masses, many of whom were illiterate. Posada brought a popular antiestablishment message to the lower classes who lived a miserable existence under the dictatorship of Porfirio Díaz. As a result, Posada was perennially out of favor with the ruling class. He lived in poverty and, along with his bosses, was periodically jailed.

Displaying obvious pre-Hispanic influences, Posada's best-known works are his skeletons, or *calacas*. Although popularized by Posada, the use of this imagery in Mexican prints actually originated with another artist, Santiago Hernandez,

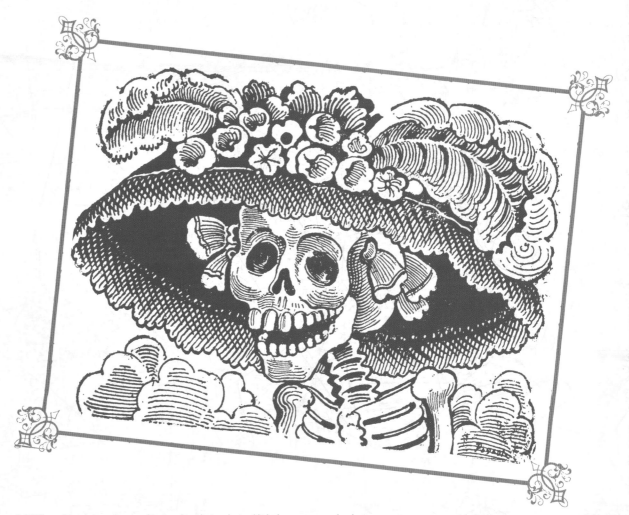

in the 1870s. Hernandez often depicted politicians as skeletons, with the intention of provoking distaste for them. Posada continued the tradition, adding a touch of humor. Dressed in various costumes, Posada's skeletons offered wry commentary on the vanities of life and were vehicles for satire.

Posada's image of Catrina, an elegant and well-dressed female skeleton wearing a large, fancy hat, is the most popular and well known of the many figures and symbols associated with the Day of the Dead. Originally meant to poke fun at the ridiculous posturing of the upper classes during Díaz's reign,

Catrina's image can be seen all over Mexico and is particularly evident during the Day of the Dead. Posada used this common name as a double entendre: in Spanish, a *catrín* is a dandy, or fancy man, so *catrina* is the female equivalent.

While Posada lived and died in poverty, the famous muralists José Clemente Orozco and Diego Rivera both knew the artist and credited his work as an influence on their own. Rivera put Catrina and her creator in his complicated mural *Dream of a Sunday Afternoon in Alameda Park*. In Rivera's interpretation of Catrina, she wears a boa and carries a parasol.

Although largely forgotten by the end of his life, Posada's work was brought to a larger audience in the 1920s by the French artist Jean Charlot, who discovered it while visiting Rivera in Mexico. Posada was an expert and prolific printmaker, creating over 20,000 images during his career. With a style that is easily identified throughout Mexico, his work forms a cornerstone of the Mexican artistic tradition, and Day of the Dead art in particular.

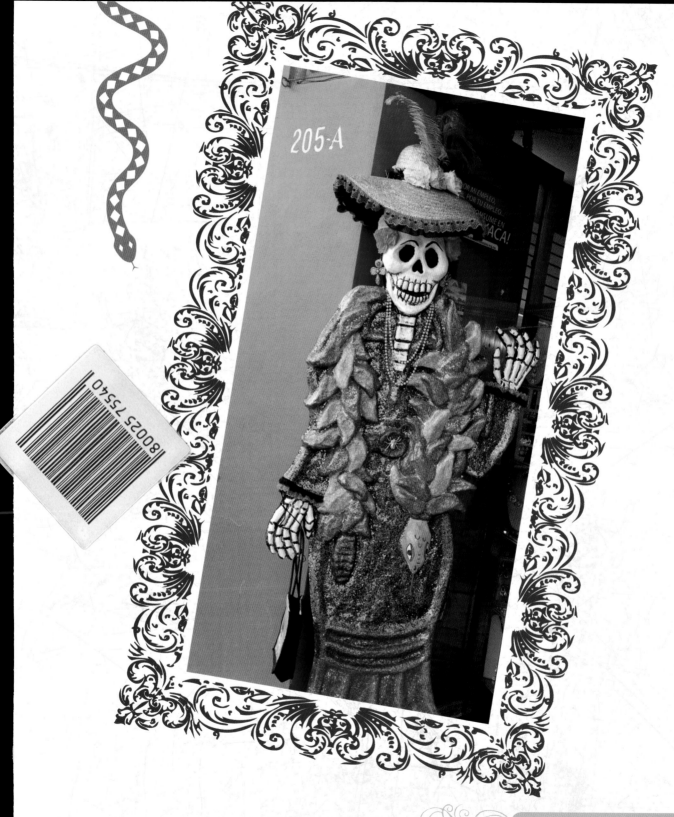

205·A

CONTEMPORARY FOLK ART

Art plays a vital role in the celebration of the Day of the Dead. While the *ofrendas* and graves are certainly decorated with a strong eye for their aesthetic appeal, the holiday has also inspired a vibrant folk art tradition. Many professional artists create folk art for sale, but much of the art is created by the people themselves, for use on their personal *ofrendas* or in other aspects of the festivities.

Traditionally, the majority of folk art had an ephemeral quality. Meant to last only a short time, the materials used symbolized the fleeting nature of life itself. Thus the care and effort with which each item was created underscored the importance of life, however impermanent it might be.

Skulls and skeletons, and particularly the Catrina figure, are common subjects of Day of the Dead artwork. Artists working in clay, wood, papier-mâché, or other materials create skeleton,

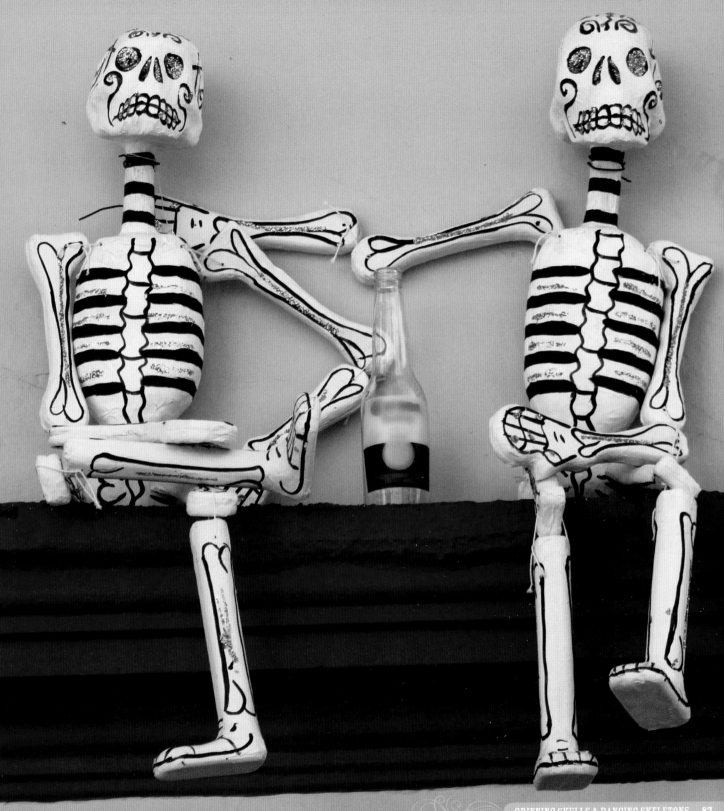

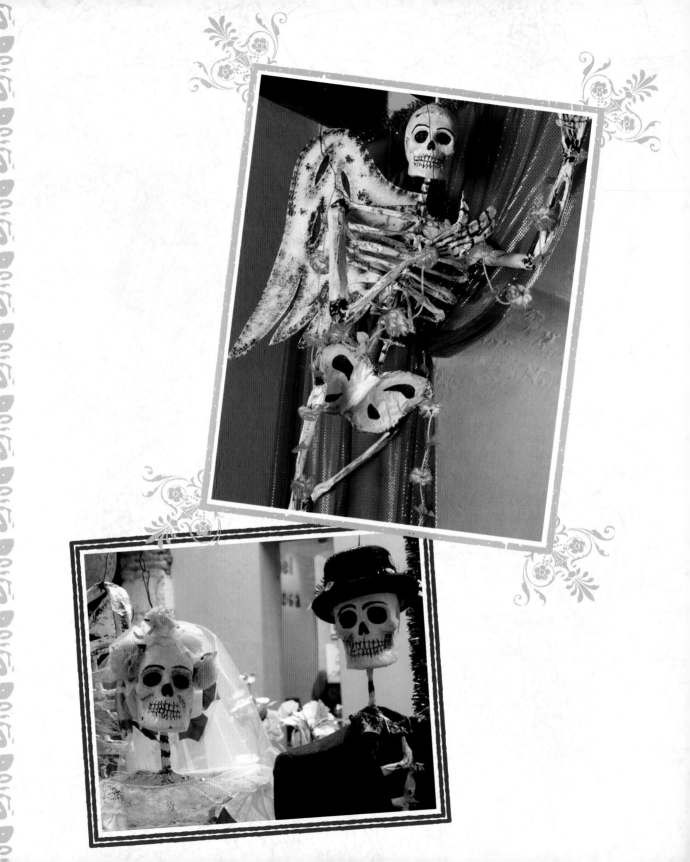

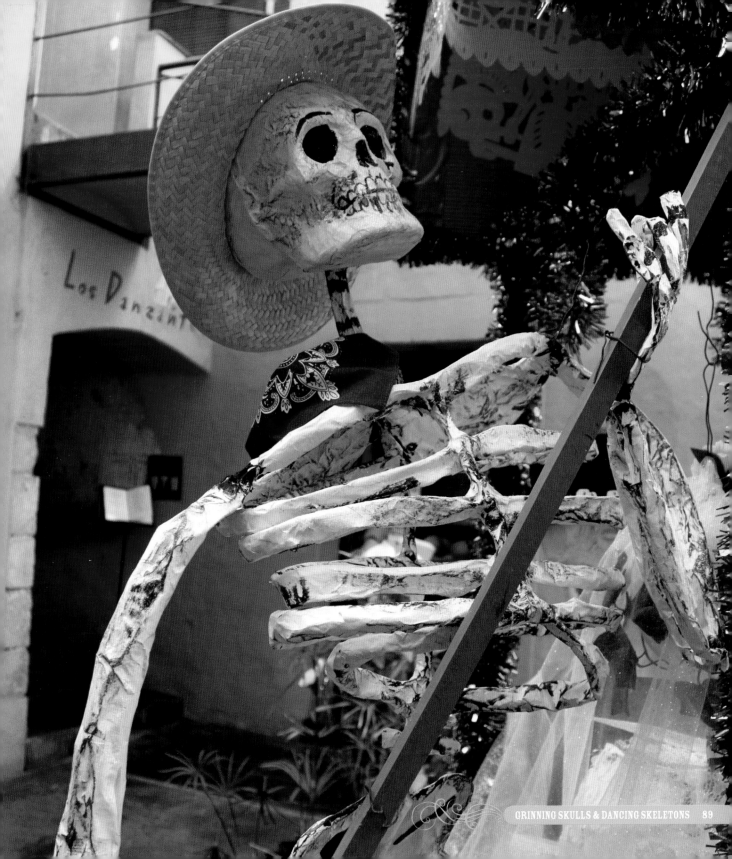

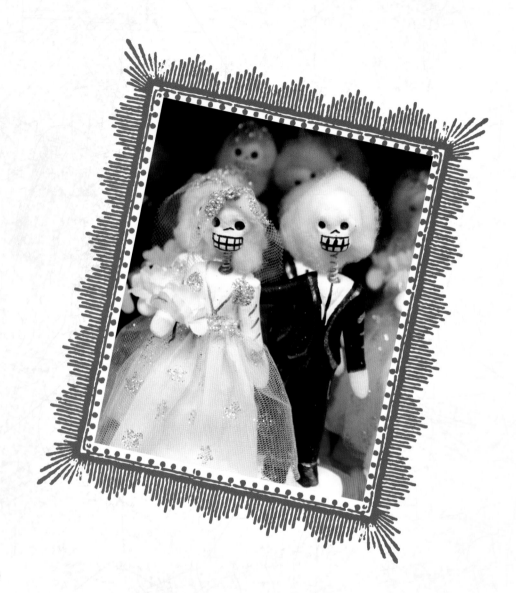

THE BRIDAL COUPLE is also a very popular theme. Often presented as a gift to a newlywed couple, the skeletal bride and groom symbolize a love that will endure even after death.

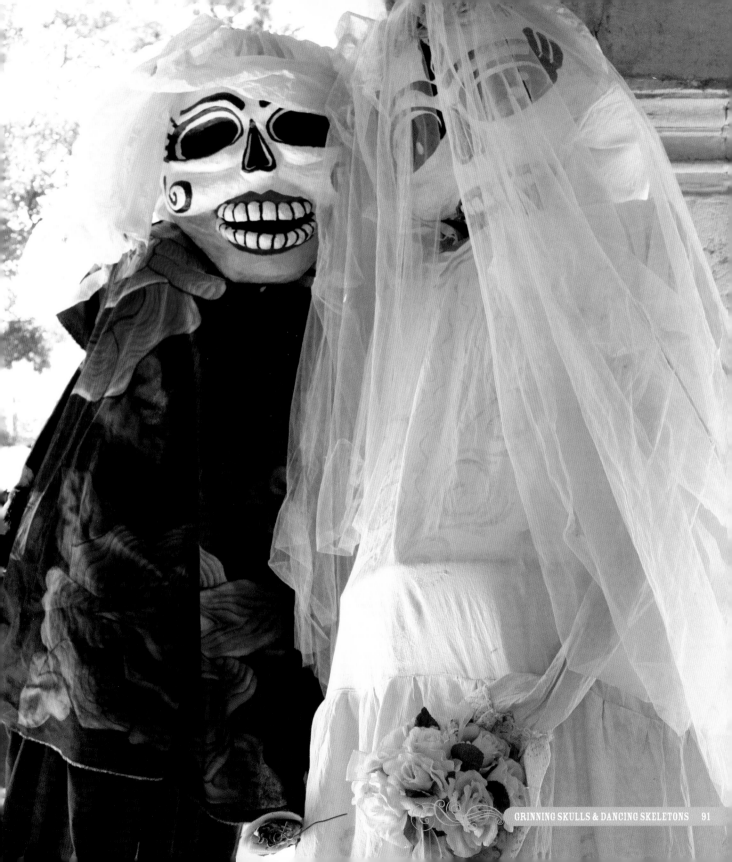

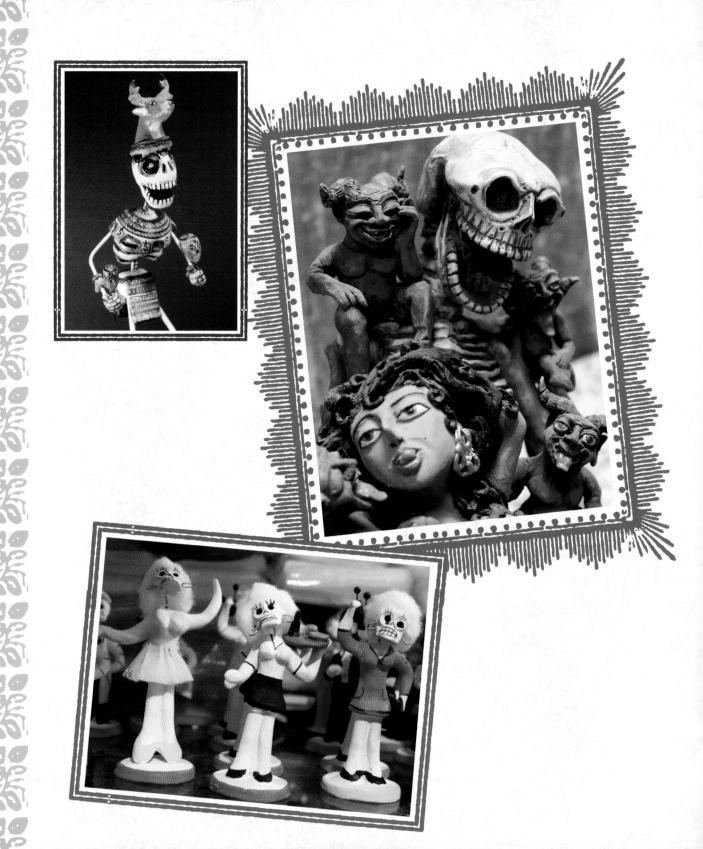

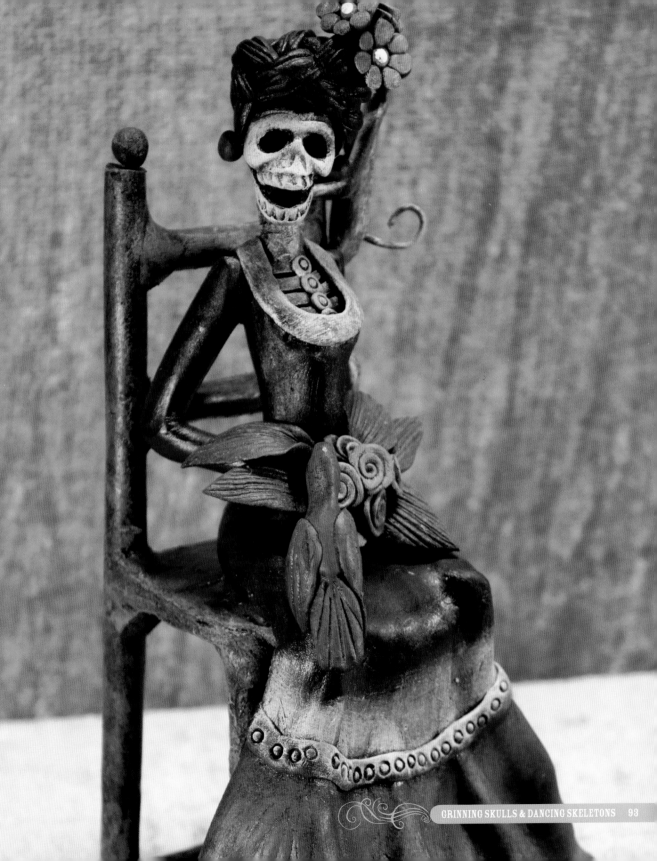

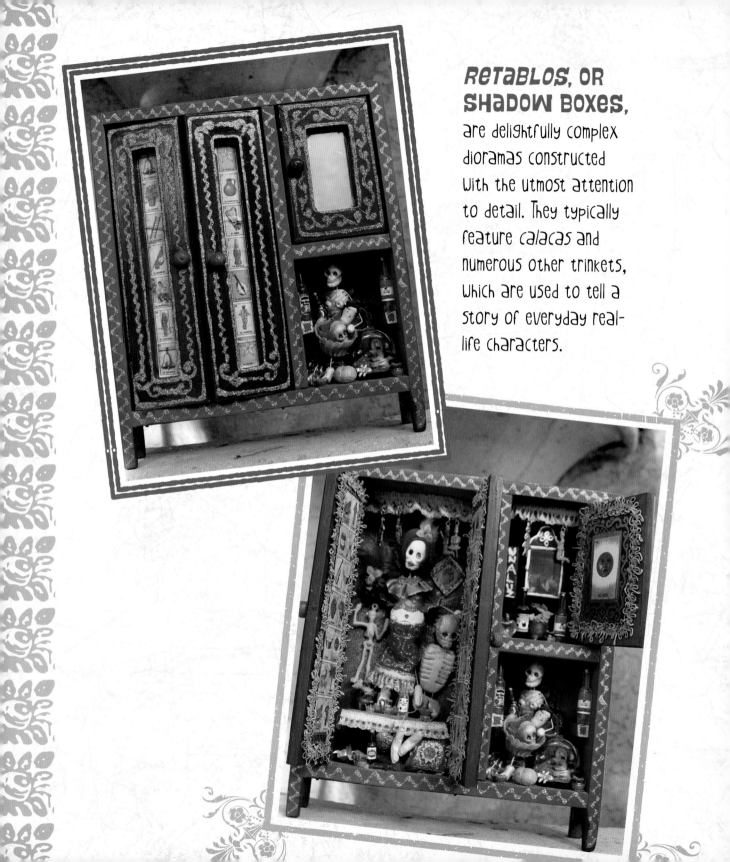

RETABLOS, OR SHADOW BOXES, are delightfully complex dioramas constructed with the utmost attention to detail. They typically feature *calacas* and numerous other trinkets, which are used to tell a story of everyday real-life characters.

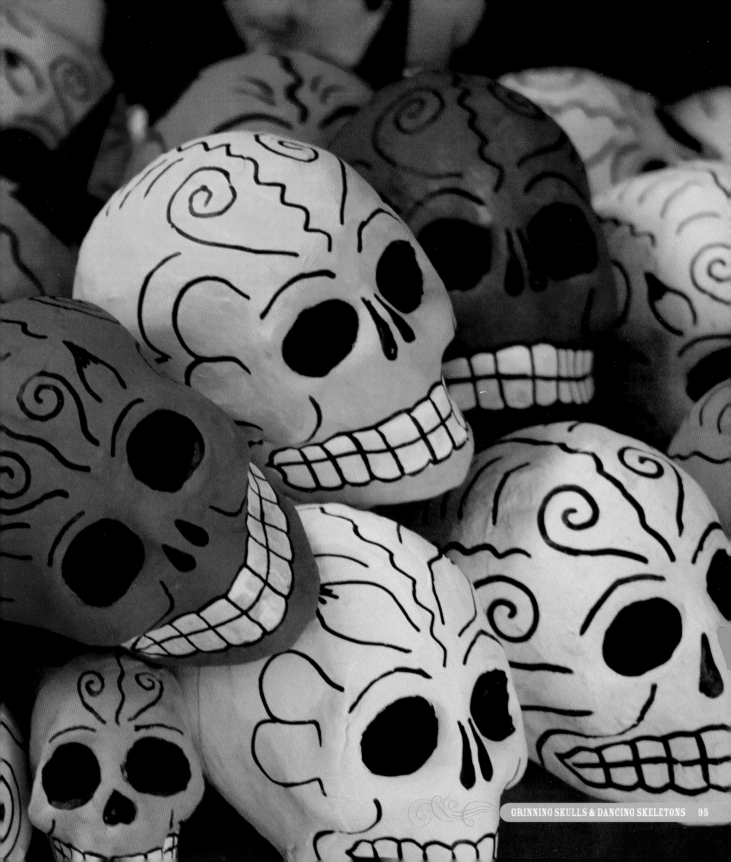

Monos de Calenda

Gigantic papier-mâché puppets known as *monos de calenda* sometimes make an appearance for the Day of the Dead in Oaxaca. For over 100 years, these puppets have been an important part of religious festivities. Accompanied by the music of a band, the *monos de calenda* dance and entertain the crowds at parties held before the religious ceremonies.

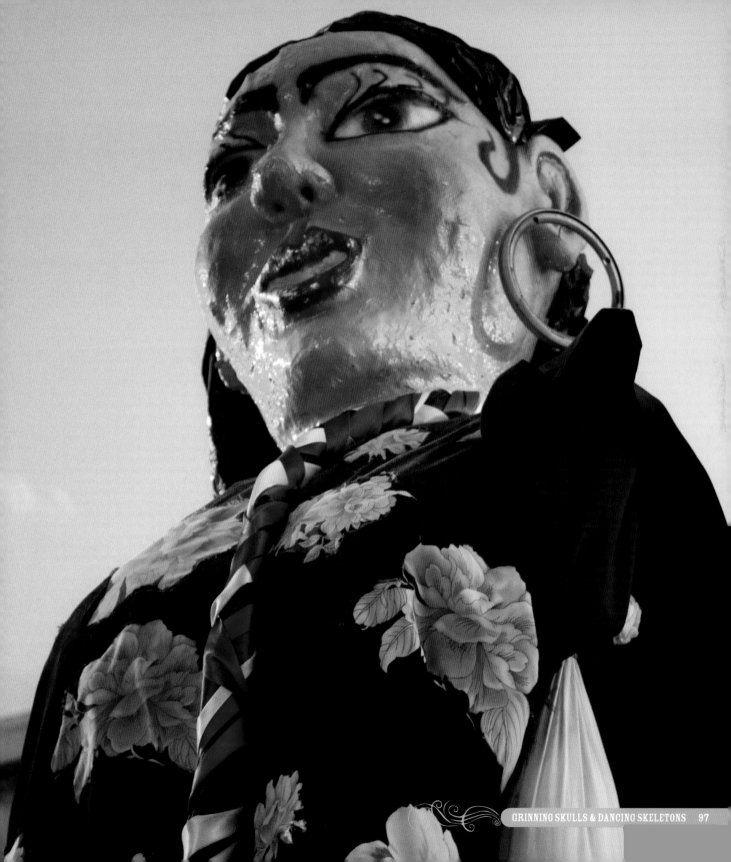

Monos de calenda usually have human forms, although the specifics may vary with the occasion. The puppets are constructed with frames of reed or bamboo, and topped with large papier-mâché heads with hair and painted features. Giant clothing in traditional styles is draped over the frames, and the women puppets are adorned with oversized earrings and necklaces.

Inside the reed base a compartment is outfitted with inner tubes so the puppets can be worn comfortably on the shoulders of the performers. Even so, *monos de calenda* often stand as much as 15 feet tall and weigh over 25 pounds.

Artists may work for over a month to create a *mono de calenda*, depending on the weather and how long it takes to dry at each stage of the construction. There is great demand for the puppets, which are rented by the day. Depending on the type of fiesta, people will request specific figures. A man and woman are common, but for weddings it may be a bride and groom, and for the Day of the Dead, Catrinas and devil figures.

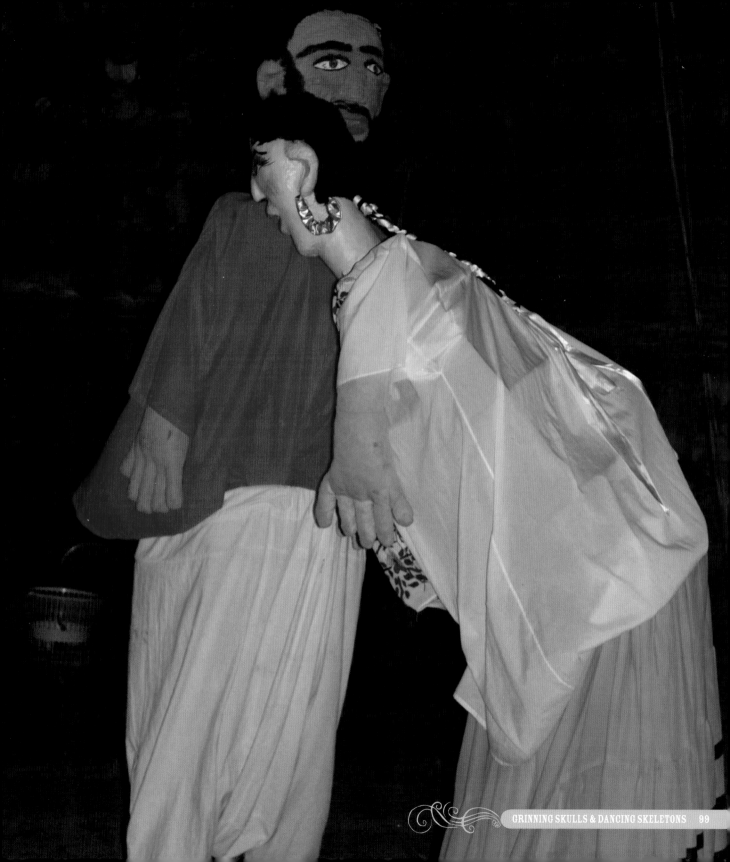

Sand Reliefs

Sand paintings and reliefs are another popular art form. Particularly in Oaxaca, intricate sand paintings are often created on the floor in front of the *ofrendas*. The artists work for hours to design elaborate images using glittery, colored sand. In the end, these artworks will be swept away, yet another symbol of life's fragility and impermanence.

On a larger scale, community sand sculpture reliefs are built in the central square, or *zócalo*, of Oaxaca City several days before the celebration. Working in brick enclosures of about

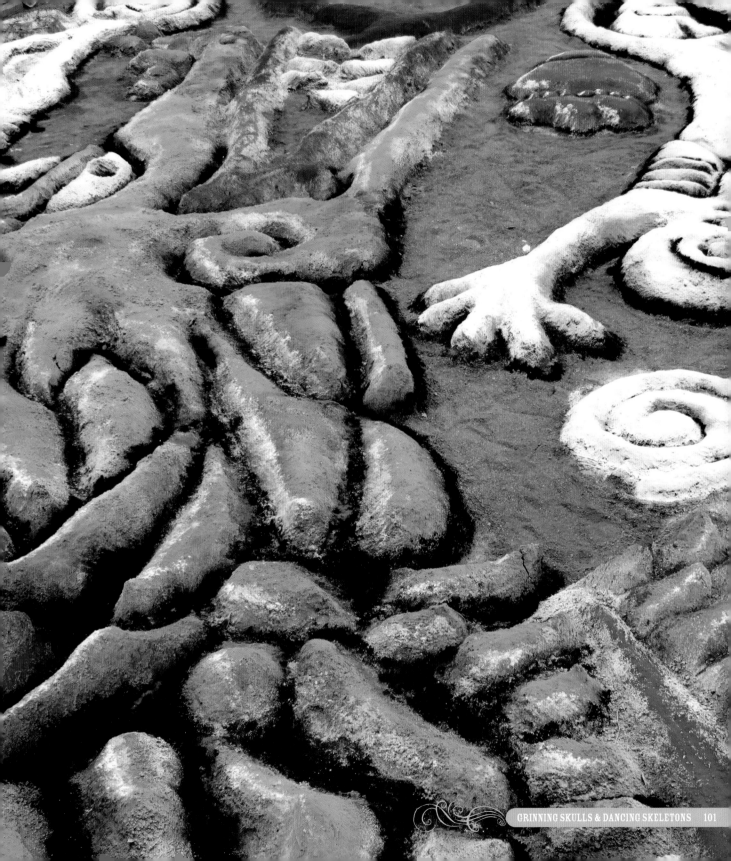

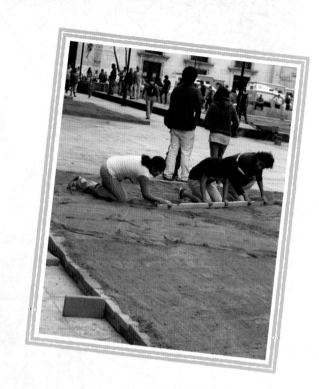

working in brick enclosures of about 12 feet by 15 feet that are filled with sand, students and other groups of artists sculpt their designs, which often include skulls, skeletons, crosses, and coffins.

12 feet by 15 feet that are filled with sand, students and other groups of artists sculpt their designs, which often include skulls, skeletons, crosses, and coffins. The artisans moisten the sand with water as they work. Once the reliefs are formed, dried plaster in a variety of colors is sifted through strainers to highlight the designs. Great attention is given to the skeletal forms of the figures, and the large scale of the works contributes to their dramatic impact. Fascinated locals and visitors alike often stop to watch as the work progresses.

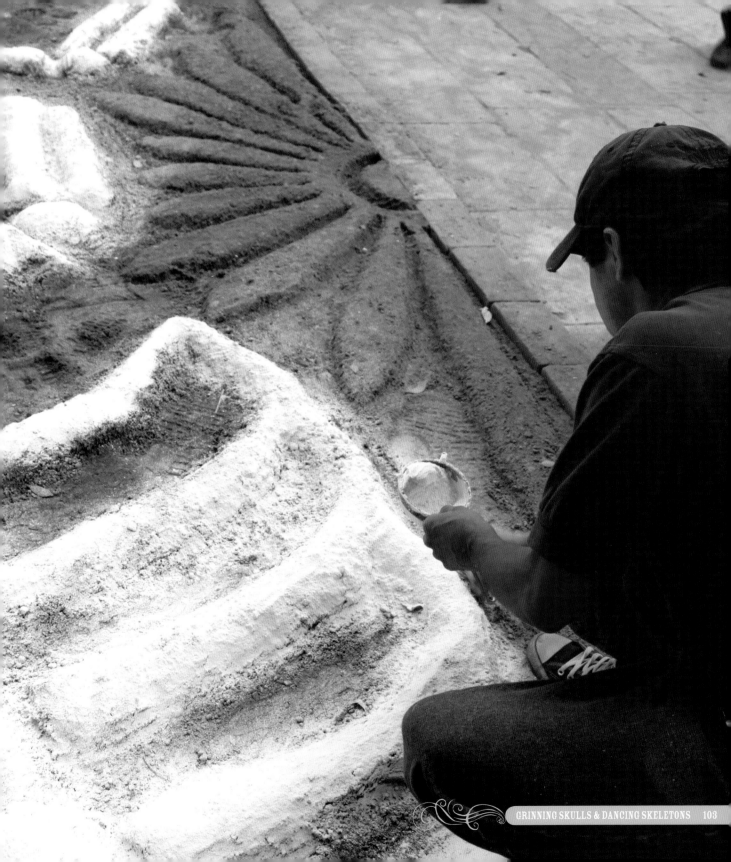

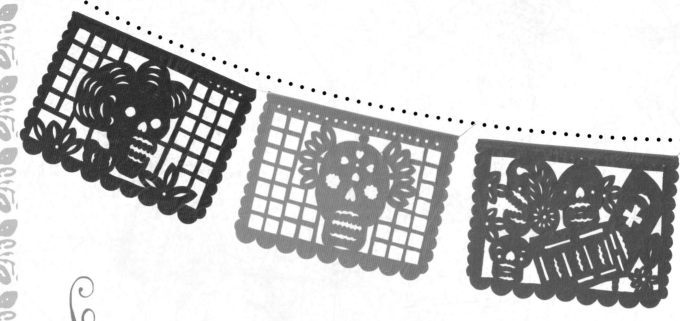

papel picado is usually cut with small, sharp chisels, known as *fierritos*. Artisans can work with as many as fifty layers of colored tissue paper at a time. The complicated designs may incorporate human and animal figures, floral patterns, lattice-work, and lettering.

Papel Picado

Colorful paper banners, or *papel picado*, can be found hanging above the streets during any Mexican fiesta or celebration. Traditionally made of tissue paper, the banners are hung together like a string of flags. Color schemes and designs vary depending on the holiday being celebrated. For the Day of the Dead, the banners are often in vibrant tones of pink, orange, and purple, and feature designs of skeletons, skulls, crosses, tombstones, and of course the ubiquitous Catrina.

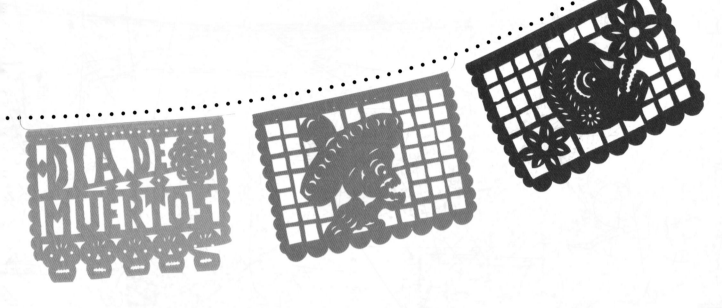

The tradition of *papel picado* can be traced to pre-Hispanic times, when papermaking thrived throughout Mesoamerica. The bark of the amate tree, a type of fig, was used to make a rich brown- or beige-colored paper. Cut-paper figures representing human and animal spirits were used in Aztec ceremonies. After the Spanish conquest, *papel de china* (tissue paper) was introduced and became the material of choice for *papel picado*. More recently, a version made of lightweight plastic has been gaining favor. Although not as traditional, plastic is sometimes preferred because it is sturdier and more long lasting, though it yields less intricate designs.

Some of the best *papel picado* comes from the village of San Salvador Huixcolotla in the state of Puebla. Artists there make decorations for the Day of the Dead, Mexican Independence Day, Christmas, and many other holidays, as well as custom designs for weddings and other special events.

inspired by pre-Hispanic imagery and the pivotal work of José Guadalupe Posada, contemporary artisans create folk art that contributes greatly to the humor and vibrancy of the festivities.

Papel picado artists create intricate designs that may take many hours to cut. Using awls, chisels, and special cutting blades, these skilled artisans can work with as many as fifty sheets of tissue paper at a time. A pattern placed over the stack of tissue paper guides the cutting of designs, which often include delicate windowpane backgrounds. The complex motifs require a keen ability to envision the use of negative space. Borders along the bottom and sides of the banners are usually finished with scalloped or zigzag designs.

The Day of the Dead exerts a strong influence on traditional art forms in every medium and from virtually all regions of Mexico. Inspired by pre-Hispanic imagery and the pivotal work of José Guadalupe Posada, contemporary artisans create folk art that contributes greatly to the humor and vibrancy of the festivities.

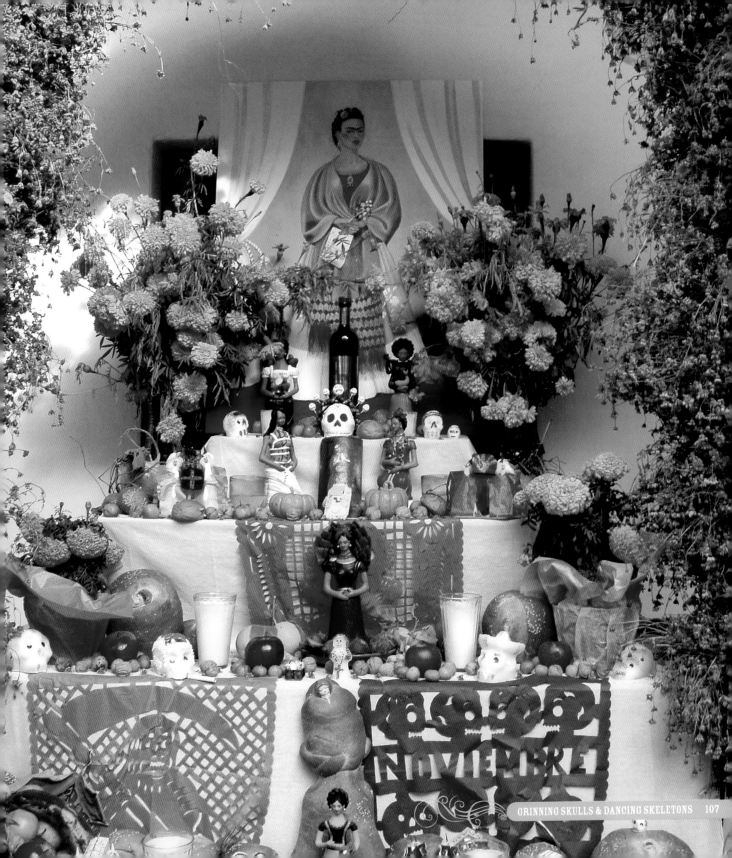

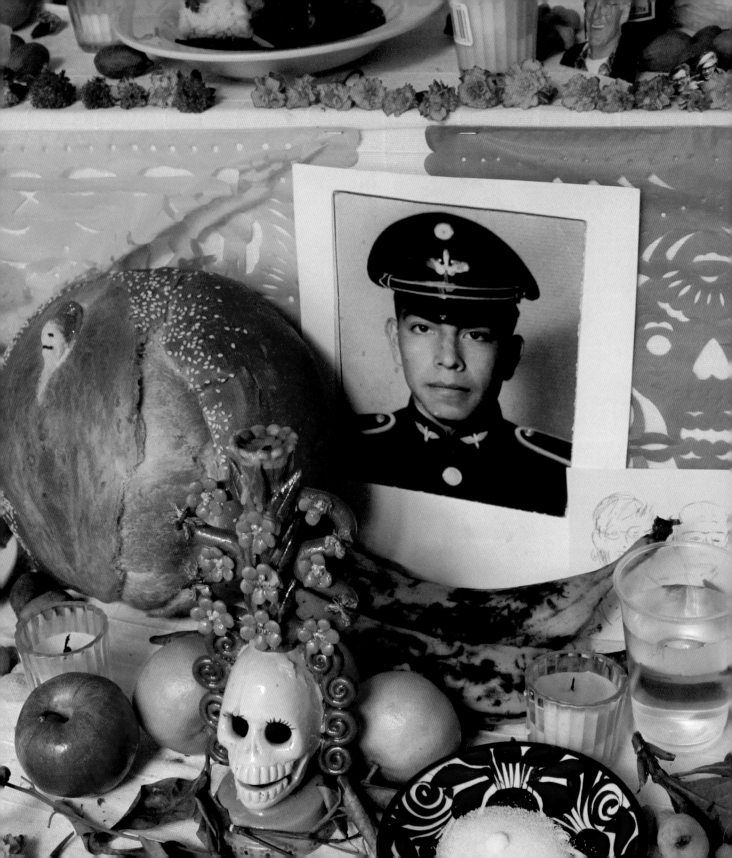

SAVORING
Tradition

CREATING A PERSONAL CELEBRATION

The Day of the Dead offers a wonderful opportunity
to remember and honor deceased friends and family members
by incorporating aspects of the traditional celebration
into your own life.

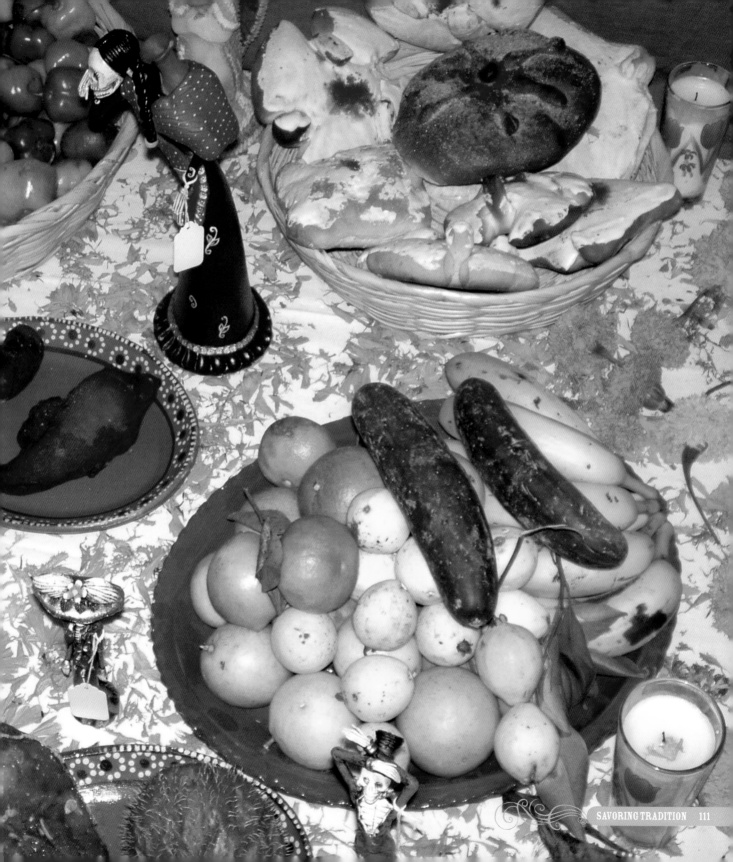

HOW TO MAKE AN OFRENDA

Begin with a small table placed against a wall or other background. It is nice, but not absolutely necessary, to have some sort of framework above the table that you can decorate as well. Cover the table with an attractive cloth, perhaps something that belonged to the person being honored, or in his or her favorite color.

Include any or all of the following items on your *ofrenda*:

Traditional Elements

- Glass of water
- Candles (representing fire)—at least one for each person being honored
- Fruits and vegetables (representing the earth)—use fresh, dried, plastic, papier-mâché, or anything else you'd like. . . .
- *Papel picado* banners (representing the wind)—you can make these or purchase them
- Dish of salt
- *Copal*—incense sticks in *copal* scent are available in some places; see the Resources section on page 128
- Marigolds (fresh, dried, or silk), or other orange, yellow, or magenta flowers—the more flowers, the better; when making an *ofrenda*, feel free to subscribe to the "more is more" philosophy

- *Pan de muerto*—if you live in an area where there is a Mexican *panadería* (bakery), it will likely have it for sale at this time of year; or you can make your own using the recipe on page 120

Personal Items

- Framed photograph of the person being honored
- Small, personal items that belonged to the deceased: a watch, piece of jewelry, hat, belt, handkerchief, etc.
- Favorite foods or beverages: a plate of food, a candy bar, bottles of beer, wine, etc.

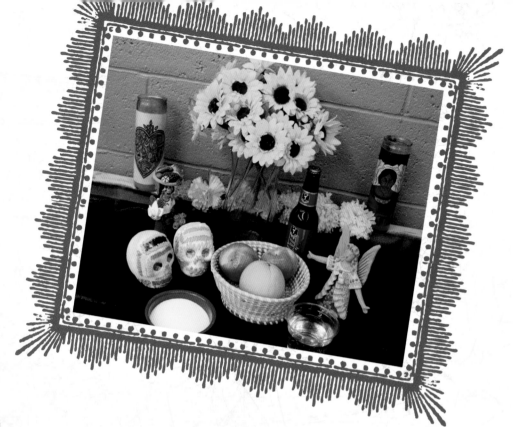

Decorative Items

• Sugar skulls—these are easy and fun to make by following the directions on page 115, or you can purchase them; you can also find or make decorated skulls in plaster, papier-mâché, ceramic, or other materials

• Skeletons made of papier-mâché, ceramic, or other materials; the sky is the limit here—there is a wide variety of fabulous Day of the Dead folk art available

Assemble all the elements and arrange them as you like. While the components of most *ofrendas* are similar, each reflects the individual creative talents of its maker. The possibilities are truly endless.

Making an *ofrenda* is a wonderful family activity. It provides a nonthreatening environment for children to ask questions about death and dying, and also gives them an opportunity to learn more about family members they may not have known or not have known well.

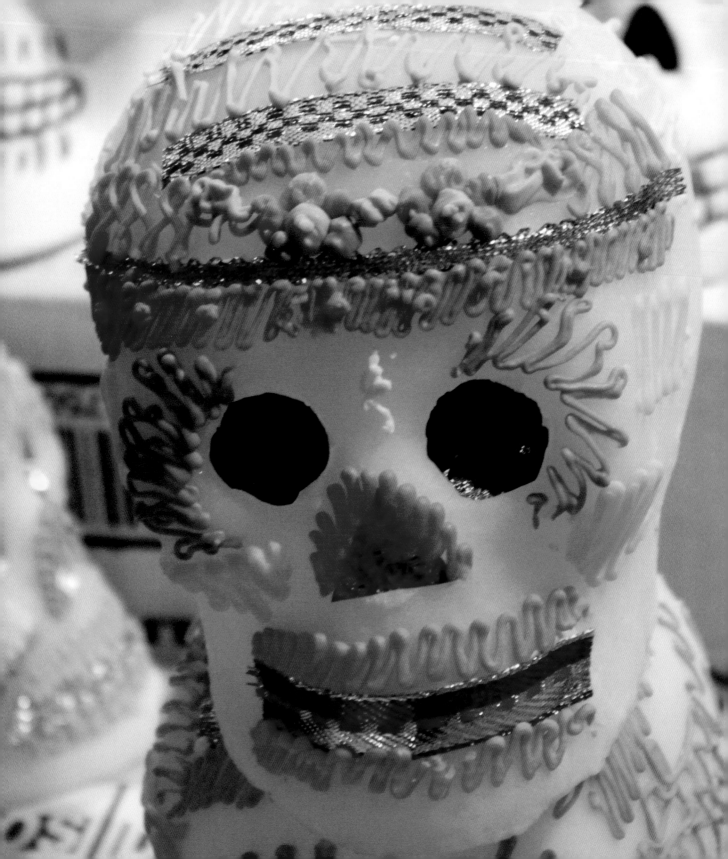

HOW TO MAKE & DECORATE SUGAR SKULLS

The sugar skulls sold in the markets for Day of the Dead are made using a complicated process involving boiled sugar and clay molds. But you can easily make your own skulls at home with just sugar, meringue powder,* water, and special plastic molds (available from several of the vendors in the Resources section on page 128).

Ingredient quantities vary depending on the number and size of skulls being made. A general guideline is 1 teaspoon of meringue powder and 1 teaspoon of water for every 1 cup of sugar. Use the table for larger quantities:

Mold Size	Number of Skulls	Pounds of Sugar	Meringue Powder	Water
Large	10	10	1/2 cup	7 Tbsp
Medium	40	10	1/2 cup	7 Tbsp
Large	5	5	1/4 cup	3 Tbsp
Medium	20	5	1/4 cup	3 Tbsp

MATERIALS FOR MAKING THE SKULLS

- Plastic skull molds
- Cardboard cut into approximately 5- or 6-inch squares (one for each skull part—front and back—being made)
- Measuring cups and spoons
- Plastic bin or large mixing bowl for sugar mixture

***Note:** Good quality meringue powder is crucial for success. For best results, use professional grade meringue powder (as opposed to hobby shop brands), which is available from the vendors listed in the Resources section on page 128.

Tip: The skulls do not dry in the molds, so you can make many skulls in a single session using just one mold.

How to Mold Sugar Skulls

Sugar
Meringue powder
Water

1. Put the sugar and meringue powder in the plastic bin or large mixing bowl and mix thoroughly. Make sure the meringue powder is completely dispersed throughout the sugar.

2. Measure the water into the mixture and mix with your hands. The mixture should feel like damp beach sand, and it should clump when you squeeze it.

3. Hold the mold in your hand (when working with the medium-sized molds, they'll be easier to handle if you cut the two pieces apart). Scoop some of the sugar mixture and press it firmly into the mold. Pack the mold with sugar as tightly as possible. Use one of the cardboard squares to scrape any excess off the back of the mold. If working with large skulls, you can make the sugar go further by hollowing out your skull a little. Just scoop out a small hole in the back, making sure to leave at least a half-inch border all around so it won't be too fragile.

4. Place a cardboard square over the back of the mold and flip the mold over so the cardboard is on the bottom. Carefully lift the mold up and off the molded sugar. If any part of the skull gets nicked in the process, simply dump it back into the bin and try again. When you are satisfied with your skull, place the cardboard with the molded sugar on a table or other flat surface to dry. Depending on the humidity, it may take anywhere from an hour to a day for your skull to dry.

Tip: If you make sugar skulls on a rainy or humid day, allow additional time for drying.

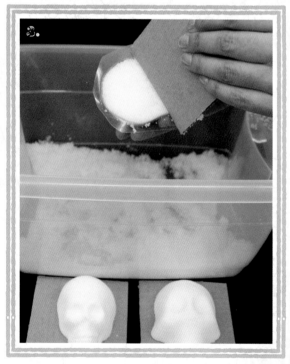

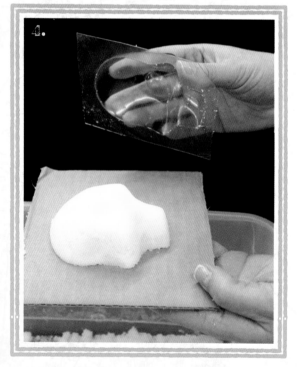

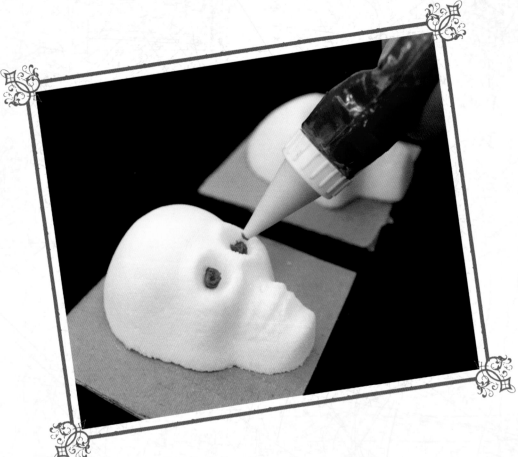

How to Decorate Sugar Skulls

MATERIALS

- Royal icing (recipe follows)
- Hand or countertop mixer for royal icing
- Smaller bowls for mixing icing colors (one per color)
- Decorator bags and tips for royal icing
- Paper plates or plastic trays (to use as a work surface and to hold your decorating materials)
- Colored foil candy wrappers (holiday versions of Hershey's Kisses have great colors!)
- Sequins, beads, or plastic jewels
- White glue or glitter glue (the water in the glue will dissolve the sugar a bit, but this can create an interesting incised effect)

Royal icing is often used for decorative confections. While technically edible, it dries rock hard so is rarely consumed. This recipe yields enough icing to decorate 5 large or 20 medium-sized skulls.

ROYAL ICING RECIPE

2 pounds powdered sugar
½ cup meringue powder
⅔ cup water
Paste food coloring

1. Put the powdered sugar and meringue powder in the bowl of a mixer. Blend with a spoon to distribute the meringue.

2. Add the water in small increments with the mixer on low speed. After the ingredients are well blended, turn the mixer on a higher speed and mix for 9 minutes.

3. Distribute the icing in smaller bowls, one for each color of icing you want to make. If you are working with two-part skulls (front and back) reserve some uncolored icing to use to glue the two sections together.

4. Add about ⅛ teaspoon of paste food coloring to each bowl and mix thoroughly. A word of warning: paste food coloring is extremely concentrated and will stain skin and clothing.

5. Assemble decorator bags and tips and put one color of icing in each.

DECORATING SUGAR SKULLS

1. If you are working with two-part skulls, use the reserved white icing to attach the front and back sections. Allow time for this to dry before continuing.

2. Select the items you want to use for decorating and put them on your plate or work surface. Many decorative effects can be obtained with different colors of icing and various decorator tips. You can also use the icing to glue on items such as sequins and pieces of foil. Skulls should be fanciful and fun!

3. When you are satisfied with your creation, allow time for it to dry (several hours).

Tip: If you need more icing, don't double this recipe unless you have a commercial-grade mixer; just make another batch.

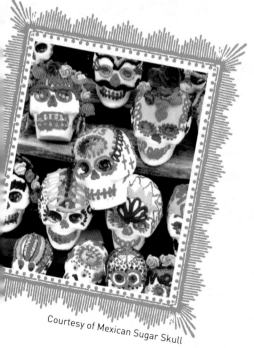

Courtesy of Mexican Sugar Skull

TRADITIONAL RECIPES

Savor the flavor of Mexico in your personal Day of the Dead celebration with these traditional recipes.

Pan de Muerto (Bread of the Dead)

MAKES 2 LOAVES

1 cup milk
½ cup butter, softened
½ cup sugar
1½ teaspoons salt
1 teaspoon finely grated orange peel
½ teaspoon ground anise
1 envelope (1 tablespoon) active dry yeast
¼ cup warm water
2 whole eggs plus 3 egg yolks
1 teaspoon water
5–5½ cups all-purpose flour

FOR GLAZE (OPTIONAL)

½ cup sugar
⅓ cup orange juice
Colored sugar for decoration

1. Scald the milk by heating to just under the boiling point, about 180 degrees F (80 degrees C). Put the butter, sugar, salt, orange peel, and anise in a large bowl and pour the hot milk over all. Stir until the sugar is dissolved and then set aside to cool.

2. Meanwhile, stir the yeast and pinch of sugar into water and let stand until the yeast dissolves and swells.

3. In a small bowl, beat the whole eggs together with the egg yolks. Spoon 2 tablespoons of the beaten eggs into a small bowl or cup. Stir in 1 teaspoon water and refrigerate for later use.

4. Stir the softened yeast and remaining beaten eggs into the milk mixture. Stir in enough flour to make a stiff dough. Turn out onto a lightly floured surface. Knead at least 10 minutes, until smooth and elastic, adding more flour as needed. Clean and oil a large bowl. Place the dough in the bowl, turning to grease all sides. Cover with a clean, damp towel. Put in a warm place and let rise until doubled in bulk (about 1 hour).

5. Punch down dough and turn out onto your work surface. Let rest while greasing two baking sheets.

6. Divide the dough in half, and then set aside about ½ cup from each half. Shape each of the large pieces of dough into a smooth, round loaf. Place on the prepared baking sheets and brush with some of the reserved egg mixture.

7. Divide 1 of the small pieces of dough into 3 equal pieces. Roll 2 of the pieces into 8- or 9-inch ropes. Press down the ends of each rope with your fingers to flatten slightly so they resemble the knobs

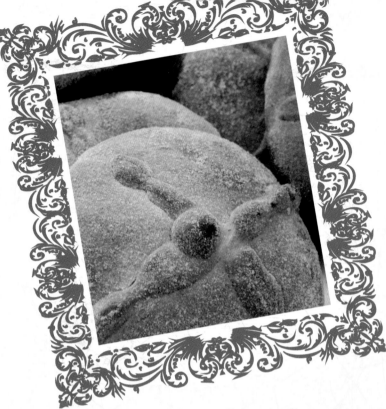

on bones. Cross the "bones" over the top of one loaf, stretching as needed so the ends nearly reach the bottom of each side.

8. Shape the third piece of dough into a ball and moisten the bottom with the egg mixture. Place the ball in the center of the crossbones, pressing firmly.

9. Repeat process for the other loaf. Cover both loaves loosely with towels and let rise in a warm place until doubled in bulk, about 45 minutes.

10. Preheat oven to 350 degrees F (175 degrees C). If not glazing the loaves, brush them evenly with egg mixture and sprinkle with a little sugar (about 1 tablespoon per loaf), if desired. Bake 30 to 35 minutes, or until browned.

11. If glazing the loaves, make the glaze while the bread is baking. Combine the sugar and orange juice in a saucepan and bring to a boil. When the bread comes out of the oven, remove it from the baking sheets and move to wire racks to cool. Put the baking sheets under the wire racks to catch the drips, then pour the glaze over the loaves. Sprinkle colored sugar on the loaves, if desired.

Mole Sauce

There are many varieties of *mole*—Oaxaca alone is known as the "land of seven *moles*." *Mole negro* from Oaxaca and *mole poblano* from Puebla both contain the spicy chile and chocolate combination that most people associate with *mole*.

Making *mole* is a complicated, time-consuming process, which is why it is customary to serve *mole* for holidays and special occasions. Recipes often call for some thirty ingredients and five different kinds of chile.

Fortunately, an alternative that provides nearly the same flavor in less time and with a lot less effort is to use a prepared *mole* paste. Paste for *mole poblano* is more common than *mole negro,* but if you are able to obtain *mole negro* paste, it is prepared roughly the same way as *mole poblano,* with a few additions (often tomatoes, garlic, and bread crumbs). If you find *mole negro* paste, ask for instructions where you purchase it.

Oil or lard
1 jar *mole poblano* paste*
1 tablet Abuelita or other Mexican chocolate (optional)
Chicken (or turkey) broth

1. Heat the oil or lard in a large skillet or saucepan.
2. Add the chocolate, if used, and heat until melted. Add the *mole poblano* paste and sauté until soft.
3. Gradually add the broth, stirring to avoid lumps. Use as much broth as needed to obtain the desired consistency (most people prefer *mole* fairly thick). A rule of thumb is about four parts broth to one part *mole* paste, so if you're using a standard 8.25 ounce jar of *mole* paste, you'll need about 4 to 5 cups of broth.
4. Serve the *mole* sauce with chicken or turkey (serving suggestions follow).

***Note:** *Mole poblano* paste can be found in the Hispanic foods aisle of many supermarkets, or is available from MexGrocer.com, listed in the Resources section on page 128; Doña Maria is a popular brand, but there are others.

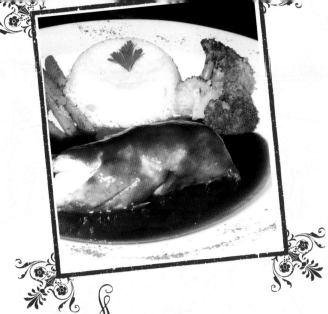

Mole sauce is generally served over chicken or turkey. Here are some serving suggestions:

CHICKEN OR TURKEY IN MOLE

1. Place cooked turkey or chicken pieces in a large, flameproof casserole dish. Pour the sauce over the turkey or chicken pieces and simmer for 30 minutes.

2. To serve, place a piece of the meat on a plate and top with additional *mole* sauce. Sprinkle with toasted sesame seeds. Serve with rice and warm corn tortillas.

Note: You may want to strain any broth left from cooking the chicken or turkey and use it to make the *mole* sauce

CHICKEN MOLE ENCHILADAS

1. Soften corn tortillas in hot oil and fill them with seasoned, shredded chicken.

2. Roll filled tortillas and place seam side down in a baking dish.

3. Pour *mole* sauce over the enchiladas and bake until heated through.

4. Garnish with a little Mexican *crema* (or sour cream), toasted sesame seeds, and a few thin slices of raw onion, if desired, and serve.

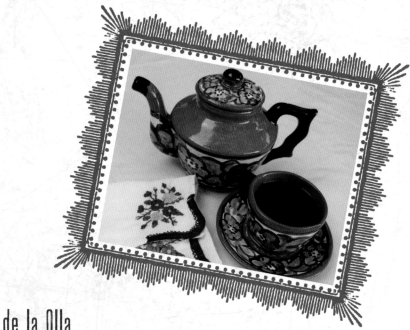

Café de la Olla

This sweet, cinnamony coffee is traditionally prepared in a clay pot, or *olla*. If possible, try to do the same, as it does affect the flavor.

4 cups water
½ cup *piloncillo**
4 cinnamon sticks
⅔ cup freshly ground coffee

1. Heat the water, *piloncillo*, and cinnamon sticks over medium-high heat in a medium pot or *olla*, stirring frequently to make sure the *piloncillo* dissolves and doesn't stick to the pot. Bring the mixture to a boil. Once it is boiling and the *piloncillo* is well dissolved, use a strainer to remove any cinnamon residue. Reduce heat and continue boiling for 10 minutes.

2. Add the coffee and stir until the mixture returns to a boil. Continue boiling for 5 minutes more.

3. Remove the pot from the heat, cover, and let stand for a few minutes. Strain the mixture using a fine sieve or cheesecloth.

4. Serve hot in clay cups (if possible) and enjoy with a sweet bread, such as *pan de muerto.*

***Note:** These hardened cones of dark sugar are widely used in Mexico and are available from MexGrocer.com, listed in the Resources section on page 128. Or you can substitute dark brown sugar (add 2 tablespoons of molasses for a more authentic taste).

Atole

 This popular Mexican beverage has a long history. Its roots can be traced back to the Aztecs (the name comes from the Nahuatl word *atolli*), and as with many foods in Mexico it is derived from corn. The most traditional times to serve *atole* are Day of the Dead and Christmas. Chocolate-flavored *atole* is called *champurrado*. Fruit flavors are also popular additions to *atole*.

½ cup *masa harina* (*masa* flour, also used for making tortillas)
5 cups milk or water (can use either by itself or a combination, according to taste)
5 tablespoons grated or finely chopped *piloncillo**
1 cinnamon stick or 1 teaspoon ground cinnamon
1 vanilla bean (split lengthwise) or 2 teaspoons vanilla extract

1. Place the *masa harina* and milk or water in a blender and blend until smooth, about 3 minutes (this step is optional but helps to reduce lumps).
2. Pour the contents of the blender into a medium saucepan and heat over medium heat, stirring constantly, until it begins to thicken.
3. Add the *piloncillo* and cinnamon.
4. Scrape the seeds from the vanilla bean into the pan or add extract. Stir vigorously until sugar is dissolved.
5. Bring to a boil, stirring constantly to avoid lumps.
6. Remove the cinnamon stick and serve hot in mugs.

***Note:** These hardened cones of dark sugar are widely used in Mexico and are available from MexGrocer.com, listed in the Resources section on page 128. Or you can substitute dark brown sugar (add 1 tablespoon of molasses for a more authentic taste).

CHAMPURRADO
Follow the same steps as for making *atole*, but after removing *atole* from heat, stir in 1 tablet (about 3 ounces) chopped Mexican chocolate until completely melted and blended.

FRUIT-FLAVORED ATOLE
Again follow the same steps as for making *atole*, but omit the cinnamon. After removing *atole* from heat, mix in coarsely pureed pineapple, strawberries, or other fruit, or 1–2 tablespoons fruit preserves.

Dulces de Calabaza (Candied Pumpkin)

This is a traditional Mexican sweet, and one that is often served for the Day of the Dead. Please note that you need to use a sugar pie or other cooking pumpkin; the decorative Halloween-type pumpkins are not meant for cooking or eating.

1 (2- to 3-pound) whole pumpkin (to obtain 1 quart of pumpkin pieces when chopped)
1 cup chopped or grated *piloncillo* (optional)*
2 cinnamon sticks or 1 teaspoon ground cinnamon (optional)
1-inch piece fresh ginger, peeled and chopped into 3 or 4 smaller pieces (optional)
¼ teaspoon ground cloves (optional)
½ teaspoon ground nutmeg (optional)
2 tablespoons ground cinnamon
¼ cup sugar

1. Cut the pumpkin in half and remove the seeds and as much stringy pulp as possible. Cut the halves in half again and remove the skin using a vegetable peeler or kitchen knife. Try to preserve as much of the flesh as possible. Cut the pumpkin into 1-inch-square chunks. Measure to make sure you have approximately 1 quart of pumpkin pieces.

2. Place the chunks of pumpkin in a fairly heavy saucepan and add water until all pieces are covered. Cover and bring to a boil for 15 minutes.

3. Add the *piloncillo,* cinnamon sticks or ground cinnamon, ginger, cloves, and nutmeg, if desired.** Cover and boil for another 15 minutes. Turn off the heat and let the pumpkin sit in the spiced syrup for at least 8 hours or overnight.

4. In the morning, return to a boil for another 5 minutes. Use a slotted spoon to remove the chunks of pumpkin and place them on a drying rack set over waxed paper. Make sure that none of the pieces are touching each other. Let dry for at least 10 to 12 hours. If you are in a hurry, turn your oven to its lowest setting and place the pumpkin in the oven with the door ajar for 3 to 4 hours.

5. After the pumpkin has dried, mix together the 2 tablespoons cinnamon and sugar and roll each pumpkin piece in the mixture.

*Note: These hardened cones of dark sugar are widely used in Mexico and are available from MexGrocer.com, listed in the Resources section on page 128. Or you can substitute dark brown sugar (add ¼ cup of molasses for a more authentic taste).

**Note: All of these spices are optional. Some cooks prefer to make *dulces de calabaza* with nothing more than pumpkin and sugar.

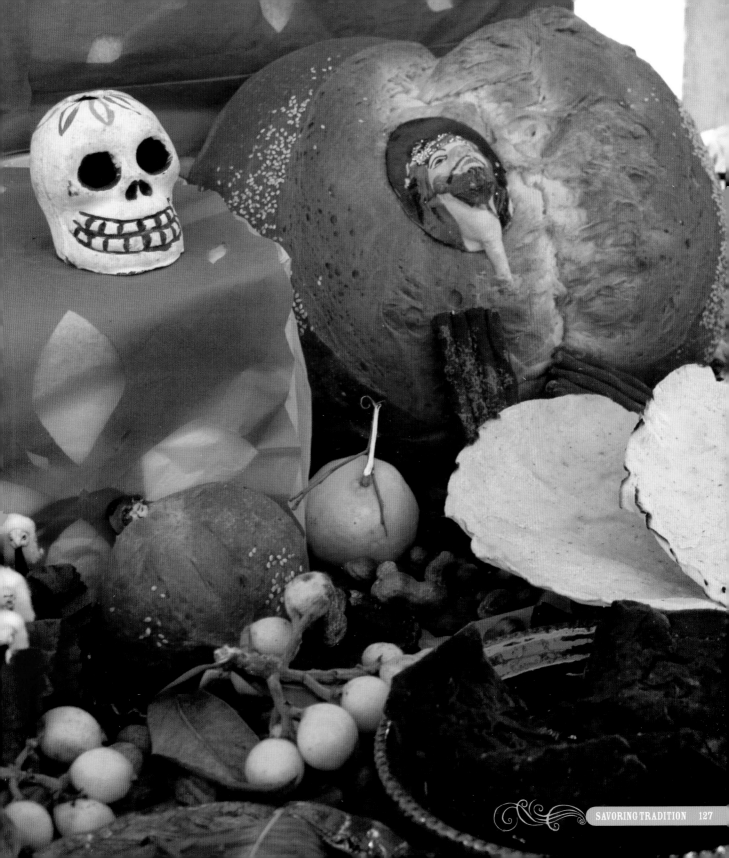

Resources

Casa Bonampak
1051 Valencia St.
San Francisco, CA 94110
www.casabonampak.com
1-888-722-4264
info@casabonampak.com
Day of the Dead folk art, jewelry, paper flowers, papel picado, sugar skulls, greeting cards, and accessories.

CRIZMAC Art and Cultural Marketplace
1642 N. Alvernon Way
Tucson, AZ 85712
www.crizmac.com
Blog: www.crizmac.com/artandsoul
520-323-8555
customerservice@crizmac.com
Sugar skull molds, meringue powder, papel picado, and Day of the Dead–themed children's books. The company also offers art and cultural tours to Mexico over the Day of the Dead led by the authors of this book.

MexGrocer.com
www.mexgrocer.com
1-877-463-9476
Authentic Mexican food products, cooking utensils, and recipes.

Mexican Sugar Skull
4920 Pinecroft Way
Santa Rosa, CA 95404
www.MexicanSugarSkull.com
707-537-9787
Sugar skull molds, skeleton folk art, Day of the Dead jewelry, T-shirts, and papel picado.